PAINTING INTERIORS

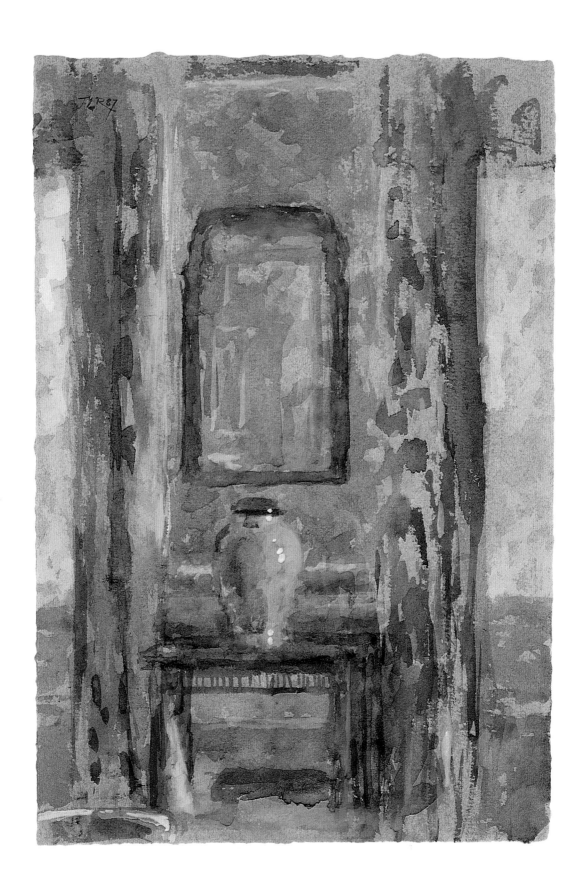

PAINTING INTERIORS

Jenny Rodwell

WATSON-GUPTILL PUBLICATIONS/NEW YORK

The author would like to thank all the artists who have contributed to this book and who have been so helpful and generous with their time.

First published in 1989 in the United States by Watson-Guptill Publications, a division of Billboard Publications, Inc., 1515 Broadway, New York, New York 10036

First published in 1989 in the UK by William Collins Sons & Co., Ltd,

Library of Congress Cataloging-in-Publication Data

Rodwell, Jenny
 Painting interiors.

 Includes index.
 1. Interior decoration in art. 2. Art – Technique.
I. Title.
N8219.I47R64 1989 758'.7'0904 88-27875
ISBN 0-8230-3646-4

Designer Marnie Searchwell
Editor Patricia Monahan
Photographs Mac Campeanu

Typesetting in Baskerville and Helvetica by Peter MacDonald and Una Macnamara, Twickenham

Colour reproduction by C. S. Graphics Pte Ltd, Singapore
Printed and bound in Singapore
by C. S. Graphics Pte Ltd

Colour reproduction by C. S. Graphics Pte Ltd, Singapore
Printed and bound in Singapore
by C. S. Graphics Pte Ltd

CONTENTS

INTRODUCTION

This book brings together a variety of paintings and drawings which belong to a category that is only just beginning to be recognized as a genre in its own right – the art of the interior.

In the past, the works of artists have always been divided into various groupings or genres, such as landscape, still-life or portraits. The painted interior has often featured as a background for a still-life or portrait, or as a kind of observation point for a landscape seen from verandah, porch or window. But until recently the interior has rarely been recognized as a genre in itself.

"I must tell you what a feeling of contentment my room gives me," the painter Gwen John once wrote. "I take my meals at the table in the window. In the evening my room gives me a quite extraordinary sensation of pleasure. I see the wide sky; this evening it is tender and calm, softening the lines of the rooftops."

The same fascination with the concept of "my room" is echoed by some of the artists in this book, who chose interiors because they wanted to paint the everyday objects and corners that have evolved as backdrops to their lives. Whereas other artists took a less personalized approach, concentrating on other types of interior, such as working environments and public places.

The Challenge of the Interior

The interior painting combines some of the characteristics of landscape and still-life and sets them in an enclosed composition with its own challenges of light and perspective. Generally speaking, landscape painters take a "macro" view – their eye sees the forest rather than the individual trees. The landscape artist often conveys an impression of valleys, woods, buildings, mountains and water by means of generalizations in which the individual objects and details merge into an overall scene. The atmosphere, the weather, are key factors affecting the light that permeates the painting.

The still-life artist tends to take a a "micro" view of the subject, frequently – though by no means always – looking for detail and for the special qualities of individual objects, as well as contemplating the group as a whole.

The interior painter seeks much of the detail, much of the intimacy, of the still-life artist, but places this in a wider context, in a "landscape" of walls. It is a confined, finite landscape as opposed to one which implies endless space. This "box" is usually the basis of the composition but it is enlivened by its contents, by the lighting, and – most important of all – by the artist's personal response to the subject.

In a sense, the interior is a still-life placed in a human context – a room which belongs to somebody or has a specific function in society.

In addition patterns, pictures, ornaments and artifacts adorn many of the rooms in which we live and work, and for many artists these are central to the subject. Such painters have a keen eye for the artistry of others – the designers of fabrics, vessels and utensils as well as the architects of the rooms themselves.

The Interior as a whole

Objects, or collections of objects, play an important role in many of the pictures in this book. But unlike many still-life paintings, interiors inevitably concentrate on the relationship between the objects and the space around them. The subject of the interior painting is the interior as a whole, not just the objects or the figures in it. No matter what the approach – the painterly treatment, concentrating on tone and colour; the topographical, with emphasis on line; or the decorative, with an eye for detail – the nature of the subject means that the relationship between objects and space still predominates.

The perspective of the landscape is therefore brought indoors to provide a sense of space in the interior composition. The viewer will notice that in some pictures a sense of privacy has been created by using linear perspective to restrict the eye so that it explores a central area, in what is technically called a "closed" composition.

There is also often a harmony of colour about an interior which gives it a sense of completeness and makes it particularly attractive, whether it is lit by daylight or by artificial light. This is because light is more confined, more varied, more affected by the immediate surroundings than in a landscape.

Light enters through a window or door or shines from an artificial source, and as it bounces off walls and objects it picks up and passes on traces of colour. If a wall is pink, for instance, a pinkness will be reflected on to nearby objects, making it easier to link one object to another in the composition. Instead of being separate, disparate elements, the objects in an interior become related to each other by the light.

As the paintings in this book show, the subject is infinitely varied. No two interiors are the same. No two artists perceive an interior in the same way. It is a "living" subject, affected by many things, including constantly changing light and the movements and activities of people in it – a fact which make interiors a rewarding and very special genre in their own right.

This painting existed in the artist's mind for two years before he painted it. During that time he planned the picture and made drawings and notes. The actual painting took about a week to complete.

Like most of David Remfry's work the painting is highly realistic but the paint is applied loosely. The composition is simple, rather graphic. His "wet into wet" technique allows colours to merge and create splendid accidental effects of texture and mottled tone that give the painting a feeling of airiness and spontaneity. If a painting becomes too dry while the artist is working on it, he sprays it with water to dampen the colours and avoid hard edges. Usually he does not draw the subject in pencil first, finding this too restricting, but for this painting it was necessary to construct the perspective of the tiled floor with pencil.

David Remfry describes his attitude to colour as "over-indulgent", he works from a wide variety of hues at any one time. His palette almost always includes cobalt violet, cobalt green and Indian red.

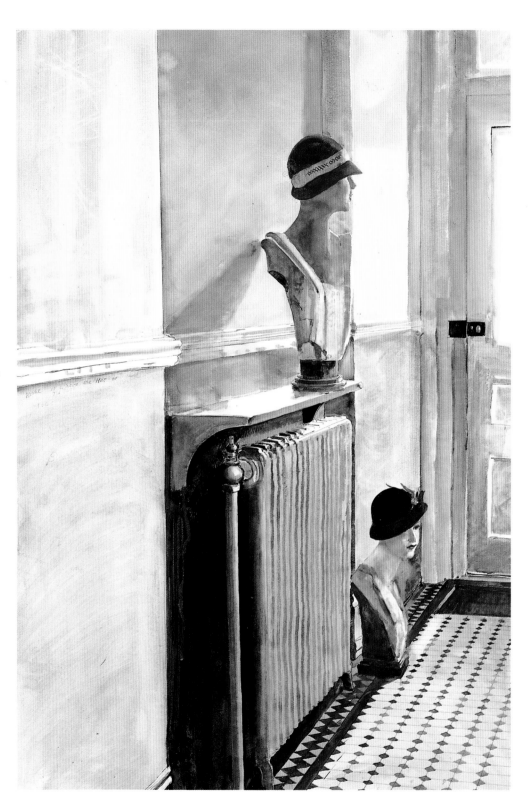

Hats in the Hall by David Remfry. Watercolour. 102cm×67cm (40in×27in)

1
DOMESTIC INTERIORS

Despite, or perhaps because of, its epic events and disasters, the 20th century has seen a growing fascination with the smaller, domestic things of life. Writers, artists and movie-makers have all reflected this in their work to a large extent. The individual has become materially richer, at least in the industrial parts of the world, and the domestic environment of ordinary people has consequently expanded and grown and is more interesting. Our lives, our love affairs, our families, our problems and our homes seem more important somehow – we count more as individuals despite our teeming numbers.

People's interest in looking inwards at themselves is reflected in the bookshop, where novels more often than not describe the relationships between individuals, and biographies are one of the most popular categories of books. It is reflected on television, where dramas and plays often concentrate on the introspective history of a family or small community. And it is also reflected in the art gallery, where more and more paintings are depicting everyday, domestic things, opening our eyes to an environment we often take for granted.

Throughout the centuries, painters have depicted the home, sometimes as a subject in its own right but more often as a background to a portrait or figure study. Familiar examples include the cool, tranquil interiors of the 17th century Dutch painters and, more recently,

the intimately observed rooms of the French artists Vuillard and Bonnard. But the domestic interior has become an even more popular subject in modern times. Many artists, such as those whose paintings appear in this book, use their own immediate surroundings and the objects of their everyday lives, as the focus of their work.

Paintings of domestic subjects attract the viewer in much the same way as a biography might attract a reader. The painted interior gives an insight into another person's life – it depicts something familiar to the viewer, yet associated with someone else. Interiors provide glimpses into other people's homes, the way they live, the furniture, ornaments and artifacts with which they surround themselves. The chance to see a fragment of someone's home can be reassuring, a comforting reinforcement of our own lives.

Pictures of domestic subjects can also be powerfully evocative, capturing an atmosphere that reminds us of other places, other people – just as the most powerful feelings of personal love can centre on someone's belongings, or objects associated with that person.

The domestic surroundings of our lives also form the most accessible subjects for the artist and are therefore ideal for amateur and professional alike. Unlike a still-life or a portrait, the domestic interior needs no arranging, no "setting up". A kitchen table scattered with the

remains of the last meal; sunlight falling on a crumpled, unmade bed; cooking utensils hanging haphazardly on a wall: these are all subjects that are already there, providing ready-made settings for the artist to paint.

Part of the fascination of interiors lies in their ability to bring into our conscious view objects which we may have come to take for granted. The domestic interior is a backdrop to our lives that we are usually too busy to notice. Often, the eye does not "see" the bathroom because it is looking for the soap. But if the bathroom is to be the subject of a painting, it must be noticed and interpreted by the artist. The shape of the room and the shapes and tones of the objects in it all become important.

This book brings together in its opening chapter a group of contemporary painters who paint domestic interiors, although they do not all have the same approach. Some, like Brenda Holtam, paint interiors just because they like the items in them. She likes kitchens because they are "full of interesting objects". Howard Morgan adopts the opposite attitude; it is most unlikely that he would ever collect things to paint. He paints whatever happens to be in front of him, concentrating on space and shape in a way that is more formal than affectionate. His approach is to go to a spot at random, face in a random direction, and paint what is there. Different again is Celia Ward, who paints bedrooms because she likes their light and atmosphere. Jacqueline Rizvi painstakingly develops the rich, resonant colours of her dining room. Antony Dufort works with the same colours, mixing anything he wants from his tried and tested palette. David Remfry attains a high degree of realism, while at the same time fully exploiting the spontaneous effects of watercolour.

Despite the variety of these paintings, they have one aspect in common. They cannot help but emphasize the intimate – recording moments of everyday life and freezing them in time.

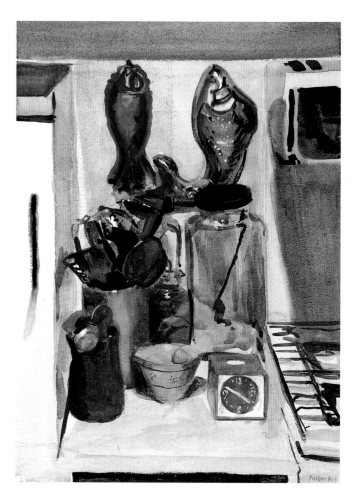

Cooking Utensils *51cm × 36cm (20in × 14in)*
by Howard Morgan. Watercolour.

These jars and utensils were painted because they happened to be there. Unlike many artists who depict interiors, Howard Morgan takes a detached view of his subjects. He does not look for "pretty" things to paint, nor does he necessarily have any particular affection or affinity for the objects in his pictures. For Morgan, it is the act of making the picture that is important, not the subject, though here he makes the subject look familiar and comfortable. This collection of objects, conveniently available in a corner of his home, provided a ready-made subject.

Cooking Utensils was completed in less than three hours – a limit imposed by the constantly changing light. "Like all paintings done by natural light, this watercolour had to be finished in one session; otherwise the whole thing would change too much," says Howard Morgan. The colours used here were Chinese white, black, barium yellow, cadmium yellow, cadmium orange, scarlet lake, alizarin crimson, cobalt violet, raw sienna, cerulean, manganese blue and cobalt blue. The support used here is heavy watercolour paper.

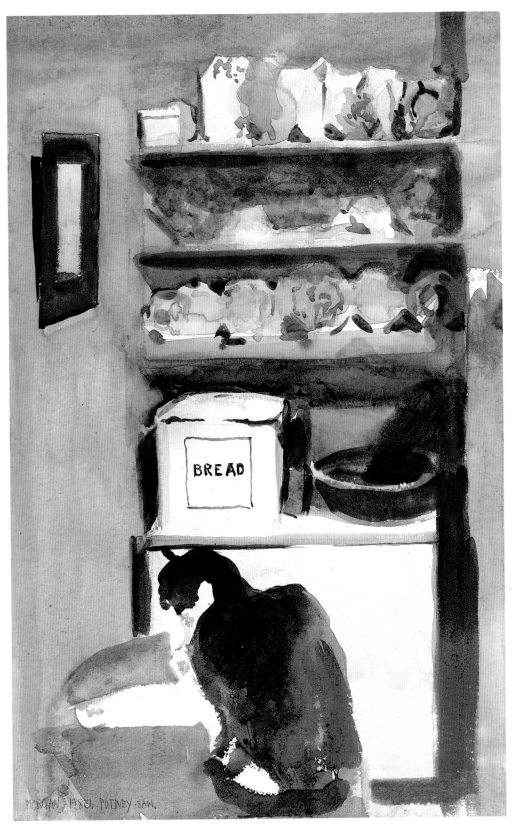

My attitude to subject matter is very detached. Looking for particular things to paint is a bad habit, a bad approach. You often end up merely with a pretty composition, like so many of the traditional watercolourists. Quite often I choose a random spot and paint four different views from that position – north, south, east and west. It is a very good way of not choosing a subject.

Howard Morgan

Sam, a neighbour's cat, allowed the artist just a quarter of an hour to paint this feline portrait. Colour was necessarily applied quickly. The artist worked with fairly large sable brushes, often adding linear detail with the pointed tip.

The artist used a palette of Chinese white, black, barium yellow, cadmium yellow, cadmium orange, scarlet lake, alizarin crimson, cobalt violet, raw sienna, cerulean, manganese blue, and cobalt blue. The support is heavy, unstretched watercolour paper.

Sam in the Kitchen *by Howard Morgan. Watercolour.* *51cm×36cm (20in×14in)*

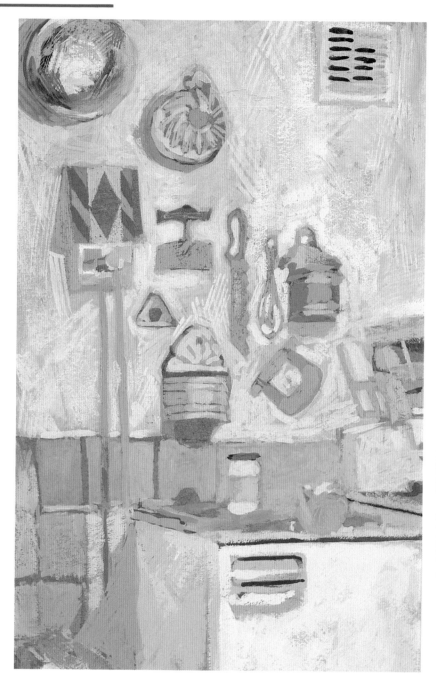

Brixton Kitchen by Brenda Holtam. Gouache on cardboard. 20cmx13cm (8inx5in)

The warm brown colour of the sized cardboard provided the artist with a ready-made mid-tone against which she could assess all lighter and darker tones, enabling her to speed up the initial stages of the painting. No preliminary sketches were used, instead, colour was applied directly, starting with the white background. Objects were left as negative shapes, cardboard-coloured spaces which were then established gradually in relation to their light surroundings. The earthy palette included yellow ochre, Indian yellow, red oxide, black, white and Winsor blue.

The sketches show the same feeling for tone and shape. The line and wash drawing (top) was done with a dip pen and ink; the softer drawing (bottom), in pencil.

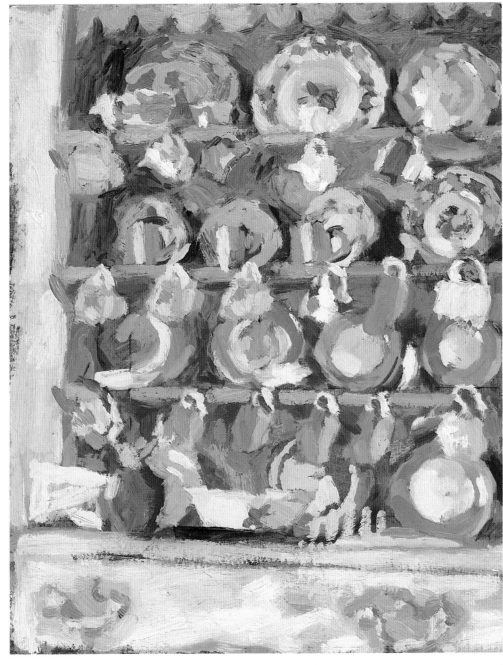

Kitchen Dresser by Brenda Holtam. Oil on cardboard. 25cm×20cm (10in×8in)

itchens always seem to be full of such interesting objects. I tend to collect kitchen items – mainly because of their shape and colour. Lighting is important too, especially sunlight. I'm always inspired by the effect of light and colour in the kitchen. It is purely visual and very exciting.

Brenda Holtam

The time available for this painting was strictly limited. Normally, even a small oil painting such as this would take several sessions, but – unusually for this painter – the work was completed in one sitting that lasted no more than two or three hours. To help speed up the project, the artist chose sized white cardboard as her support. She started by covering it with a warm neutral tint, a mixture of burnt sienna and raw umber, applied lightly with a dry brush. The colour was then rubbed in, allowing the white cardboard to glow through the thin paint. Brenda Holtam then applied paint in strokes of related tones. She worked from a palette of white, black, cadmium yellow, light red, raw umber, ultramarine blue, burnt sienna and yellow ochre.

The bedroom

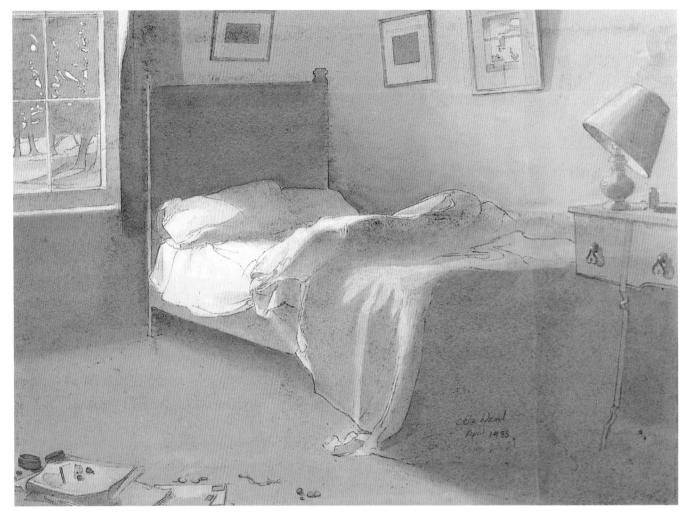

Unmade Bed by Celia Ward. Watercolour. 23cm×31cm (9in×12in)

Bedrooms, according to Celia Ward, are often the most beautiful rooms in the house, and bedrooms that are located upstairs are lighter than other rooms. These, the artist explains, are among the reasons why she likes painting them. It was the light falling on the pillows and crumpled sheets that prompted this particular study, which is one of a series featuring beds and bedrooms.

As with most of her interior paintings, Celia Ward worked on this composition slowly over a long period of time. In order to achieve consistent light effects, she returned to the picture for a short period at the same time each day.

The paint is built up in thin layers, using the traditional watercolour technique of working from light to dark – in other words, the palest tones were laid down first, and darker colours and tones were gradually worked into these. The artist prefers to work on a sheet of paper that is larger than the anticipated size of the finished painting. This enables her to control the extent of the composition and to decide on the boundaries as she works. She usually starts with the focal point – in this case, the bed – and works outward from it. The palette for this painting consisted of burnt umber, raw umber, burnt sienna, raw sienna, ultramarine blue, Prussian blue, Hooker's green light and yellow ochre. White gouache was used occasionally to work back into the watercolour washes to re-establish light tones and highlights in the subject.

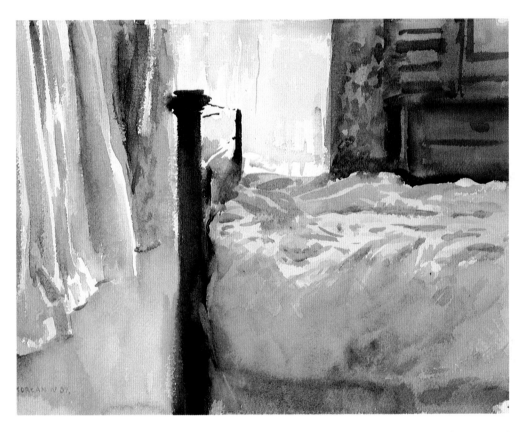

White Bedroom by Howard Morgan. Watercolour. 36cm×51cm (14in×20in)

Although many artists paint their bedrooms with a special warmth and sympathy that derive from a sense of intimacy and familiarity, Howard Morgan perceives the subject purely as an arrangement of shape, form, colour and tone. The composition is unusual, slightly discordant, with the bed and the background area dividing the picture space into rectangular shapes. The bed is parallel to the top and bottom of the paper; the sharp upright of the bed post forms a dark, uncompromising vertical. Fabrics – the curtains and bedspread –

provide a softer element, yet the overall emphasis is undoubtedly on the abstract, formal qualities of the subject.

The use of white in this painting is another departure from tradition. Classical watercolourists spurned the use of white pigment, preferring to exploit the whiteness of the paper to obtain highlights and pale, transparent tones. But in this predominantly white painting, Chinese white is used opaquely and liberally to establish the light tones of the subject.

The bathroom

Bathroom in Ireland *by Antony Dufort. Ball-point pen on paper.*
41cm×30cm (16in×12in)

The drawing (right), sketched on cheap school paper, was done by Antony Dufort when he was still at school. The other works on this page – a drawing and painting of a similar subject – were done by the same artist some 25 years later.

Brixton Bathroom *by Antony Dufort. Pencil on paper.*
20cm×13cm (8in×5in)

This is a preliminary sketch for the painting opposite. The composition and arrangement of tones – the light and dark areas of the subject – are all resolved and established at this early stage. The artist feels the drawing stage is important – "you have to be brilliant to paint directly on to canvas, so the initial drawing must be right. Otherwise you can go on adjusting the painting forever".

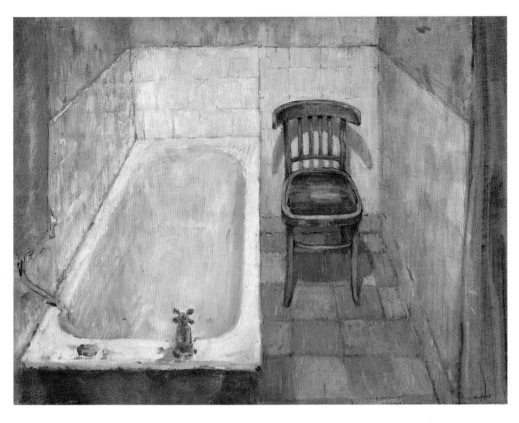

Brixton Bathroom by Antony Dufort. Oil on canvas. 61cm × 44cm (25in × 18in)

The oil painting of the artist's bathroom started in the darkroom. By projecting the drawn image directly on to the canvas through a photographic enlarger, he was able to trace a light but exact outline of the subject on to the support with a fine felt-tipped pen. This process, quicker than the laborious job of squaring up the drawing, provided an accurate guide for the paint. The method also enabled him to move the image around on the canvas in order to obtain the exact composition he required.

Antony Dufort always works with the same colours, based on the palette used by British artists Walter Sickert and Henry Tonks. These are white, black, Indian red, alizarin crimson, cadmium lemon, yellow ochre, raw sienna, viridian, ultramarine blue, cadmium yellow and scarlet lake. From this selection the artist can mix any other colours he needs. Many painters find it difficult to mix a good variety of greens, but Antony Dufort points out that with just cadmium lemon, yellow ochre, raw sienna, viridian and ultramarine blue, any type of green can be achieved. He feels cadmium lemon is the crucial colour here because no other yellow is as versatile or effective. It is especially vibrant when mixed with viridian and ultramarine.

The dining room

A dinner table, apparently laid for a meal, makes an elegant subject for the shimmering colour that is typical of Jacqueline Rizvi's work. In fact, this painting was completed slowly over a period of several weeks during which time her dining room was totally out of action.

The artist usually works directly from life, carefully building up the picture with overlaid brushstrokes of colour. She also makes detailed drawings of her subject before starting to paint. As the pencil sketch (below) shows, her drawing is strong and clearly defined, belying the softer, more amorphous quality of her paintings.

Body colour is essentially an opaque paint – in this case the body colour is white gouache – and is generally used to establish strong, solid areas of colour and tone. But in the hands of Jacqueline Rizvi, it becomes a sensitive and versatile medium. She mixes white body colour with pure, transparent watercolour, applying this in varying degrees of opacity, from completely opaque to almost transparent.

She often uses light, opaque tones in the initial stages to develop and describe the solid forms within the subject. This is then worked over with more transparent touches of paint in order to build up depth of colour and tone. In the details on the opposite page, the first stage (top left), shows a

I use various techniques in my paintings, a combination of processes in which the image is built up with touches of overlaid colour. I have really developed my own ways of working. For instance, glazing transparent layers of colour over solid underpainting – something I often do – is more often associated with oil painting than with body colour or watercolour.

Jacqueline Rizvi

section of the table, with the plates, glasses and dishes established in opaque, pastel colours. The second detail (top right) is the same area, now complete. The local colour, shadows and reflections have been worked over with thin layers of transparent colour, bringing the objects to life by giving them depth and resonance. As with most of her paintings, Jacqueline Rizvi worked on tinted paper. In this case, she chose a warm buff grey.

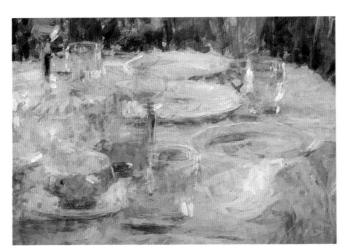
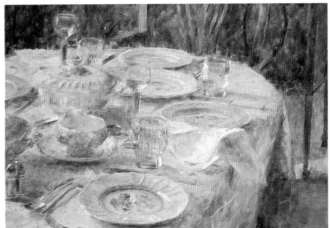

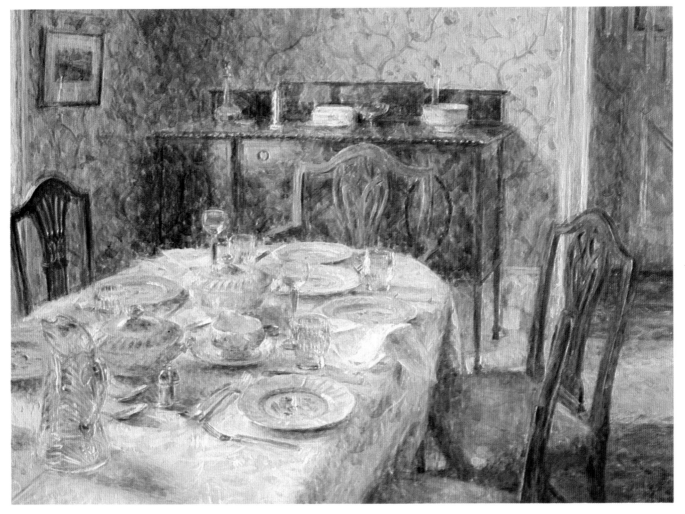

Still-life on Dining Room Table *by Jacqueline Rizvi. Watercolour and body colour.* *51cm×67cm (20in×27in)*

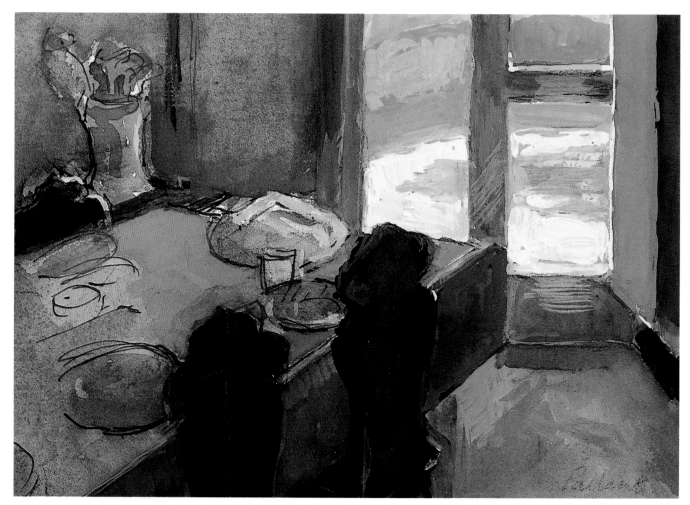

Florentine Farmhouse, *by Anna Pallant. Watercolour and gouache on paper.* *16cm×20cm (6in×8in)*

The brilliant light and contrasting shadows of the Mediterranean sunshine made a deep impression on Anna Pallant. She loved the mood created by the sunlight filtering into the enclosed space of this room, the clear, sparkling colours and deep pools of shadow.

Watercolour holds a special fascination for this artist, especially the way it creates its own colours and effects when used loosely. She started the painting with free washes of pure, transparent colour and added white gouache to the paint in order to "pull together" the image.

2
CORNERS AND CLOSE-UPS

Often the most familiar things in our lives are small portions of a room. We rarely notice these rooms as a whole and tend not to take them in at a glance the way a visiting stranger would. Instead, we become absorbed in our own activities – reading, listening to music, entertaining friends, or working – most of which are carried out at close quarters. If we go away, even to a foreign country, we still end up familiarizing ourselves with some small area of our surroundings. It is surprising how frequently we find ourselves getting to know a particular part of a room. If we spend much time there, especially if it is our home, then we become familiar with every object in that small world: a piece of furniture, a desk-top, the decoration on a wall, a set of tools, the corner of a bookshelf, a coffee table.

These close-ups and corners have a great fascination for the artist. They have the characteristics of a still-life, yet they have an extra meaning, an extra touch of humanity, because they are so well known, either to the artist, or to a person associated with the painting.

The pictures in this chapter therefore fall into a category somewhere between still-life and interior. They are details, fragments which the artist has chosen to isolate from the entirety of the surrounding room. These close-ups allow the artist to focus on an incidental object, or group of objects, which often wholly reflect the interior to which they belong but which the artist finds interesting in their own right. Unlike most still-life subjects, these interior details are rarely specially arranged. They are less formal.

When a subject is chosen purely for formal reasons – the colours, shapes and forms of an arrangement of objects perceived in isolation from any other distracting elements – then it could be classified as a still life. But frequently, the corner or fragment of the room in which the objects stand is an integral part of the image. The painting becomes a slice of an interior and includes objects, or parts of objects which remind us that they belong to a larger whole. In effect, the still life has become rather like a detail of an imagined, larger picture as if the artist has zoomed in on part of an interior.

The groups of objects in these interiors often happen to be in a part of a room that has attracted the artist for one reason or another. Perhaps it is a collec-

Familiar places

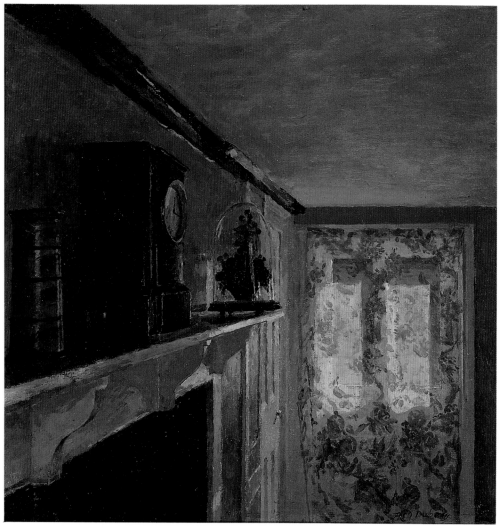

The Mantelpiece by Fred Dubery. Oil on canvas. 38cm×41cm (15in×16in)

This artist is primarily concerned with tone, with the range of lights and darks, which can run from bright white to black within the same subject.

In this painting of the kitchen mantelpiece in the artist's home, however, the range is subtle and generally dark. When working with such similar tones there is a risk of the image becoming subdued and muddy. To avoid this, the artist mixes mastic, a type of resin, with the basic oil painting mediums, turpentine and linseed oil. Mastic enhances the surface quality of the paint, keeping the blacks and dark greys alive and bright. To illustrate the effect of the mastic, Fred Dubery compares painted surfaces to the tonal quality of black and white photographs. When he uses mastic, the blacks and dark tones show up clearly, as they would in a glossy photograph; without the mastic they can look disappointingly faded and dull, like the dark areas in a matt photograph.

tion of things the artist is particularly attached to. Sometimes it is linked with an occasion or pleasant domestic routine, such as a meal. Two of the artists in this chapter, for instance, have painted their uncleared breakfast tables.

What makes many of these paintings different from others in the book is the scale of their subject. Instead of furniture arranged in a room, the artist might choose objects scattered on a piece of furniture, such as books on a table or ornaments on a mantelpiece. The painter is given the chance to look more closely, sometimes portraying a clutter of objects seen in relation to each other, like the clutter on Brenda Holtam's

desk. Repeated shapes, such as the ellipses of a collection of pots, can often be used to great effect. Occasionally, a single item can take precedence, for instance, the solitary pan on the mantelpiece in Antony Dufort's kitchen.

An impersonal arrangement of objects would not have the same flavour as these incidental fragments of parts of a room, with all their associations. The mantelpiece in Fred Dubery's painting on page 22 has appeared in many of his pictures. Yet it is not taken in impersonal isolation. Even when he paints it on its own, as he does here, there is a sense of the room around it and of the house in which it is situated.

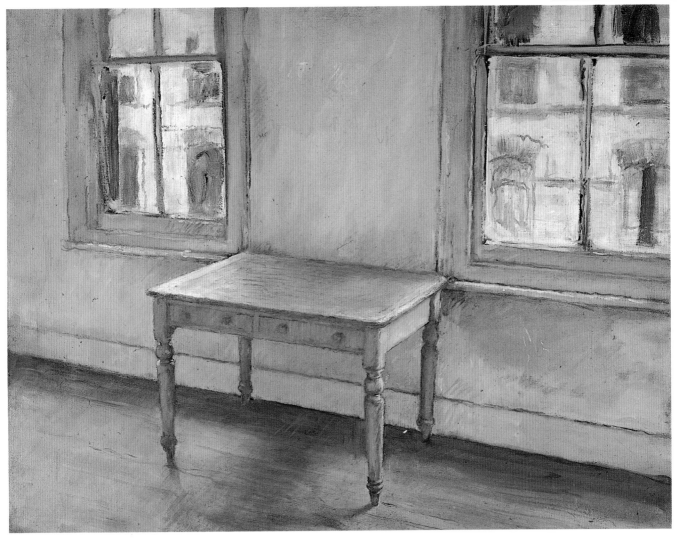

Brixton Table by Antony Dufort. Oil on canvas. 43cm×53cm (17in×21in)

Empty rooms appeal to Antony Dufort. He feels that clutter is compulsive, and that many people actually cannot live without surrounding themselves with objects and bric-a-brac. Space is vulnerable, he says, easily destroyed by too many "things"; objects "soak up" space, altering and spoiling the special quality of an empty, uncluttered room. Although Antony Dufort is an avid collector, he prefers to keep all his artifacts in one room so they won't intrude on his living and working space.

Because this room is almost empty of furniture, there are no emphatic shadows, no bright colours. The spacious simplicity of the interior is emphasized by the view through the two windows, which shows the comparitively "busy" and detailed facades of the houses opposite. Tones are light; colours, neutral. The artist captured the uneven texture of the bare plaster walls by scumbling a pale tone over a darker one: he applied the top layer unevenly, using patches of broken colour in order to allow the darker toned underpainting to show through in places. He worked from a palette of white, black, Indian red, alizarin crimson, cadmium yellow, yellow ochre, raw sienna, viridian, ultramarine blue, cadmium yellow and scarlet lake.

Interior with Manet by Brenda Holtam. Oil on primed card. 30cm×6cm (12in×2in)

We are accustomed to pictures that are rectangular or square in shape and that familiarity sometimes prevents us from really "seeing" what lies within the frame. Here, the unusually tall, thin format makes the subject initially unrecognizable, and we have to look quite carefully to discover what the painting is about.

The unconventional shape of the painting evolved by accident. Brenda Holtam had originally intended to paint an almost square picture and duly cut a rectangular sheet of cardboard to size. But she decided that the left-over strip was potentially more interesting and planned this composition accordingly.

The cardboard was treated with several coats of size in order to seal the surface and make it more receptive to oil paint. Its natural grey colour was left unprimed, providing a neutral ground for the subsequent colours. Brenda Holtam first drew the subject in paint, using diluted raw umber applied with a soft sable brush. She then blocked in the drawn composition, working simply and directly with a range of closely related tones mixed mainly from earth colours.

Finding the best composition can be quite difficult...I often look at the subject through a cut-out viewer or use two L-shaped cardboard brackets, just to give me an appreciation of the possibilities. Then I let it happen. My compositions are never formal, and the first attempt is almost always the best

Brenda Holtam

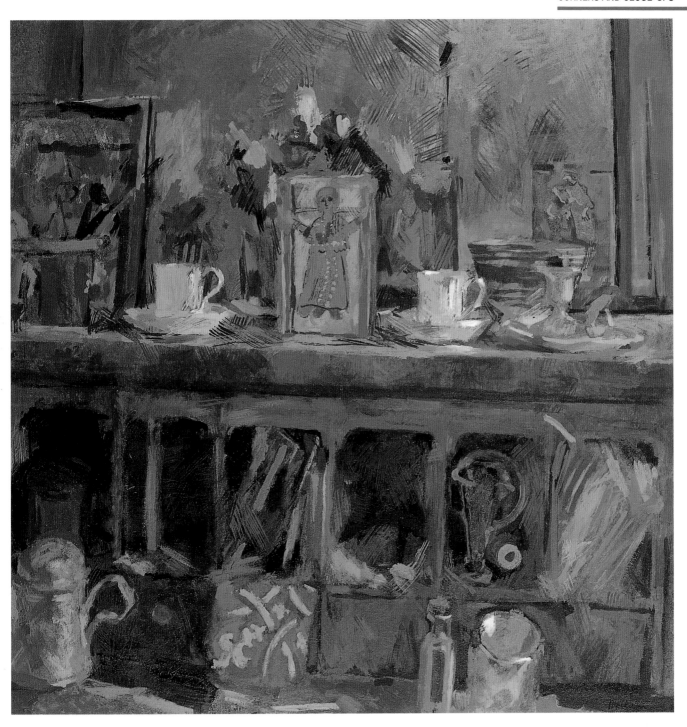

The Artist's Desk by Brenda Holtam. Oil on board.

61cm×61cm (24in×24in)

Teacups, recently bought in the market; an old floor tile; a potted plant; ornaments; papers and books. This haphazard, randomly placed collection – the contents of

Brenda Holtam's desk – provides a challenging ready-made subject for this intriguing painting. The composition is simple; the subject is placed squarely

and symmetrically on the support. The viewer's interest is focused almost entirely on the objects themselves. Nothing has been moved or arranged.

Painting in a south-facing room, the artist coped with the problem of rapidly changing light by working for a short period at the same time each day.

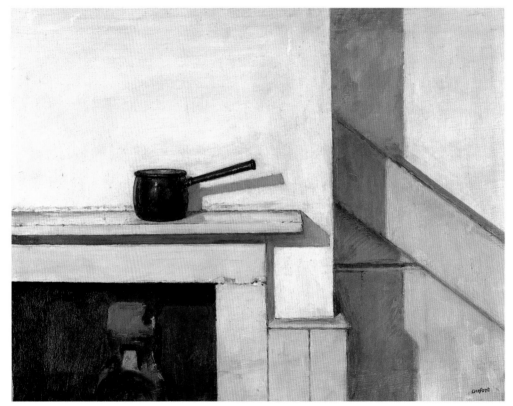

Brixton Saucepan by Antony Dufort. Oil on wood. 30cm×41cm (12in×16in)

This striking painting of a stark interior succeeds both as a realistic image and as a formal composition. Antony Dufort has described the scene accurately: the attractive and familiar form of a favourite saucepan sits convincingly on the mantelpiece of an otherwise empty room. Yet the painting would work equally well as an abstract composition. The rectangular support is rigorously divided into geometric shapes; the vertical, horizontal and diagonal lines of the interior are arranged with a deliberate tautness. There are no amorphous spaces – each area of wall, panelling and shadow is a sharply defined shape, and each of these interlocking shapes makes a positive contribution to the composition as a whole.

Antony Dufort made pencil drawings (top) before embarking on this painting, considering the subject from various angles before committing the image to paint. He then worked directly from life, painting with his usual palette of black, white, alizarin crimson, cadmium lemon, yellow ochre, raw sienna, viridian, ultramarine blue, cadmium yellow and scarlet lake.

The simple interior of this tiny Welsh church is a favourite of the artist and is the subject of many of his drawings and paintings. The composition consists of just three elements – the window, lectern and memorial stones – and the simplicity of the composition reflects the uncluttered tranquility of the church itself. No rigorous process of elimination was needed on the part of the artist, although the careful use of empty space was crucial; the negative shape of the surrounding wall is as important here as the objects themselves.

John Sergeant works in various media. He is particularly fond of watercolour, but the more linear quality of the coloured chalk chosen for this interior reflects his preoccupation with drawing – a skill that he feels is often sadly overlooked. Drawing, he says, is vitally important despite what he describes as today's "preoccupation with painterly values".

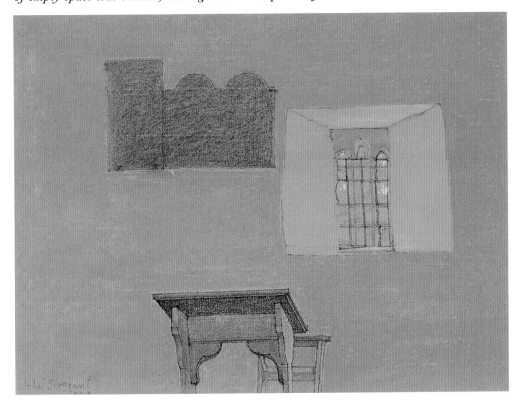

Interior: Welsh Church by John Sergeant. Chalk on paper. 23cm × 30cm (9in × 12in)

Objects "in situ"

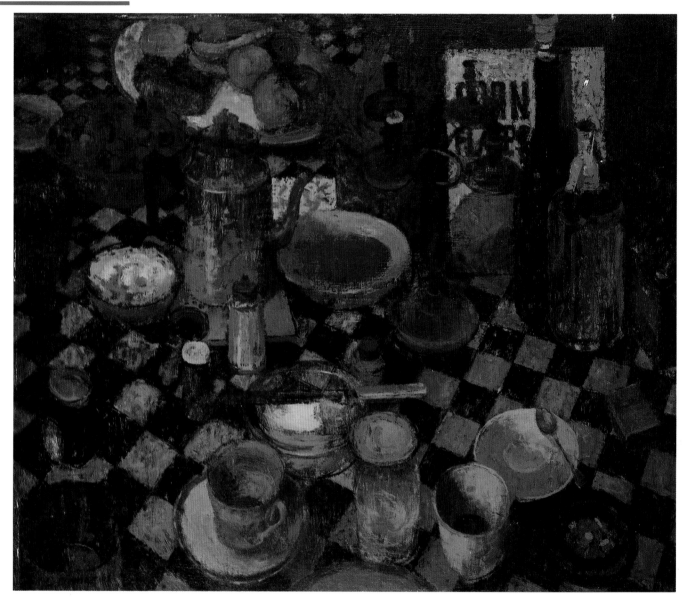

Breakfast by Lionel Bulmer. Oil on canvas. 91cm × 71cm (36in × 28in)

Painting tends to portray the pleasant side of life, depicting an orderliness that is not necessarily a reflection of the truth, says Lionel Bulmer. In this painting he deliberately set out to convey a sense of muddle, to create what he felt was a more honest impression of the general confusion of everyday existence. "Breakfast" is not, therefore, a harmonious arrangement of pretty plates and cups. It is a portrait of uncleared breakfast things, painted exactly as they were left on the table. To Lionel Bulmer, the unwashed crockery and a mundane box of cereal on the checked cloth provided a "complicated and fascinating" subject, which he painted "warts and all".

The artist worked from the subject without any preliminary drawing. He started by roughing out a broadly painted outline sketch on a canvas stained with a dark ground. He worked from dark to light, starting with the deep colours and gradually introducing light tones.

"Breakfast" was painted several years before this photograph was taken, and Lionel Bulmer points out that the dark ground has caused the whole painting to darken slightly during that time.

Noon *by Fred Dubery. Oil on canvas board.* *30cm×41cm (12in×16in)*

In this painting the subject is seen contre jour, against the light, so both the interior and the objects on the window sill appear dark against the bright noon light beyond them. Most of Fred Dubery's work is concerned with tonal values, and here the range runs from pure white to almost black – a situation the artist finds both challenging and intensely interesting.

Noon *was painted on a grey ground, a medium tone against which the extensive range of lights and dark tones could be assessed. Colour was applied opaquely – Fred Dubery uses the term "paste" when talking of the consistency of the oil paint with which he builds up layers of non-transparent colour in his paintings.*

The canvas board used for this painting was made by stretching and sticking fine muslin onto a sheet of hardboard.

Two tabletop compositions

Breakfast at the Wharf Rat *by Sophie Warbuffle-Wilson. Mixed media on paper.* *20cm×30cm (8in×12in)*

At times Sophie Warbuffle-Wilson worked with a paintbrush in each hand in order to keep the colour moving in this painting. She is not naturally ambidextrous, but she has developed the technique to the point where she can control the paint equally well with both hands. One advantage is that when painting with watercolour, she can apply paint with one hand and water with the other and thus can spread washes of colour before they have time to dry and create unwanted tide-marks.

This was the second version of the same subject. Sophie Warbuffle-Wilson frequently paints a subject twice, finding that the second attempt is usually more fluid and spontaneous than the first. This painting was done in watercolour, Chinese ink, gouache and gum arabic.

Lily *by Crista Gaa. Watercolour and gouache on paper.* 15cm×20cm (6in×8in)

A mass of tiny objects plays a major part in Crista Gaa's life. She collects anything she likes the look of – sometimes because she feels that its shape, colour, pattern or texture could be part of a painting, but often simply because a particular detail appeals to her. Her pieces, which include pottery, ornaments and shells, are not necessarily of intrinsic value; Many are "objets trouvé" – pebbles and pieces of wood picked up from the ground. There was a time, she says, when she used to carry many of these small objects around with her in a knapsack.

Crista Gaa frequently includes flowers in her paintings because they offer a wide variety of shape and colour. The orange lily in this tiny still-life provides a splash of brilliant colour that is echoed in the warm earth tones used elsewhere in the painting. Its shape, irregular and organic, sets off the solid roundness of many of the other objects. The artist followed her usual technique of starting with watercolour, then strengthening the image with gouache. Lily took about five hours to complete.

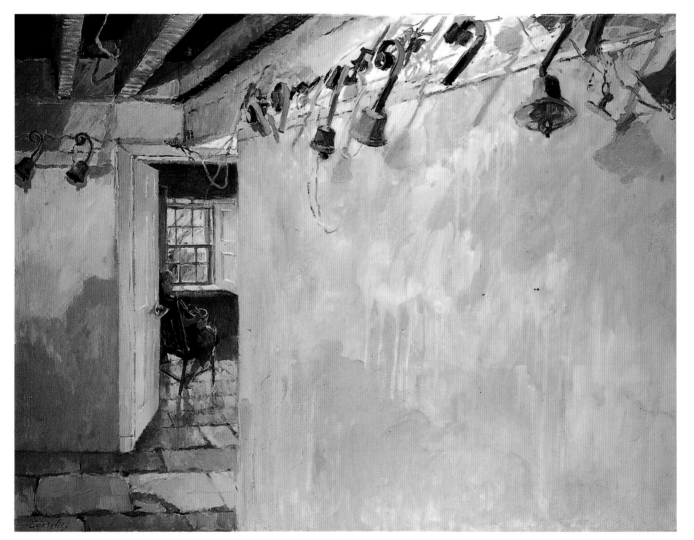

Bells of Belchester by Jane Corsellis. Oil on canvas. 76cm×106cm (30in×42in)

Nearly two-thirds of this interior is taken up by bare wall. For Jane Corsellis, this expanse, crumbling plaster and dilapidated pink wash, was not only important to the composition but also visually exciting in itself. She experimented with the paint in order to get the surface texture right, allowing the colour to drip down the canvas and blotting off layers of diluted washes in order to get the mottled appearance of the old plaster wall surface. She had to tone down the local colour and texture of the wall to create an illusion of depth.

3
DOORS AND DOORWAYS

An open door is inevitably attractive, a peep-hole into someone elses life. We like sauntering along a street looking through people's windows, especially if the lights are on and the room is illuminated. Passengers in a train often enjoy gazing briefly at the lives going on inside the houses that flash by. We hide our curiosity, perhaps reflecting a guilt bred into us since childhood – "Don't stare," and "Don't look now, but...". We live in a society that puts up curtains or blinds to prevent such inquisitive prying. This is part of the fascination of the interior painting that allows us to look through an open doorway.

A painting that includes a doorway is a picture within a picture; both painting and doorway have distinct frames. The edges of the canvas, or support, define the extent of the main composition – one that will eventually be placed in a real frame. Within the main composition, an open doorway is equally clearly defined, frequently by its own frame in the form of an architrave, or some other surround. There is a definite architectural link between these two frames. Before the picture frame we are familiar with was invented artists often painted their pictures directly on to the surfaces of alcoves, or recesses on walls, panels or screens. These were normally designed

as part of a building, and were already surrounded by a carved edge, ornate beading or architrave. Picture frames as we know them today are direct descendents of these designs.

An artist's "doorway" often opens on to the scene outside, bringing outdoors and indoors together in the same composition. The doorway becomes a frame for a landscape within an interior. This view invites the eye to escape the confines of the painted room and move out into the daylight and open spaces beyond. Such a doorway can alter the whole feeling of a painted interior. It not only brings a sense of openness and fresh air into an otherwise enclosed space, but also places the room, the interior, in a wider context by giving it a setting. A glimpse through the open door indicates whether we are in the city, in the country, or by the sea. It also tells us whether we are quietly alone in our interior, or whether there is noise and activity just outside.

The idea of a landscape painted within an interior is not new; it is a common device in both Italian and northern European painting. The outdoor view is often painted in minute detail, as a miniature landscape; its colours are often brilliant and jewel-like, thus emphasizing the difference between the

daylight and the darkness in the room. Although the clarity and detail of many of these miniature outdoor scenes contradicts an illusion of real distance and space, the eye is nevertheless pulled into the landscape beyond.

However, an open door in a painting does not necessarily look outward. Some, like Emily Gwynne-Jones' *Interior with Mugs* on page 36, are of a dark interior seen from outside. Jacqueline Rizvi painted her daughter's bedroom from the landing – very much a private interior with no indication at all of the outdoors. In her white-painted cottage on page 41, Margaret Green depicts a series of adjoining rooms, in which the doorways are stages in an extended view of enclosed, if naturally lit, spaces.

Painting views through doorways inevitably involves at least two types of light: natural or artificial, or a combination of varying strengths of both. Outdoors, natural daylight is often all-embracing; its strength and colour are dictated by many factors, including the weather, time of day and geographical location. The use of cool and warm tones, is all important when differentiating between indoor and outdoor light. Frequently the Renaissance artists painted their miniature outdoor scenes in cool green blue to contrast with the warm tones inside. This follows the principle of aerial perspective – the fact that objects in the distance tend to look bluer and hazier than those nearby.

An open doorway, whether it leads into another room or outside, can also provide the artist with an opportunity to bring texture into a picture. Many painters vary their brushstrokes in order to create space in a painting by using broad, textural strokes when painting the foreground. This contrast – which creates a varied, interesting image – is not always possible when the subject is confined by the walls of a room. But when a subject includes a view through a doorway, part of the subject is seen at close-quarters, the rest more distantly.

Apart from making drawings for paintings, I now rely a lot on written notes – particularly useful when time is short. I have my own code for colours and other things, a sort of shorthand. My notes and sketchbooks would probably not make much sense to anyone else. For a painting, I usually make a very quick "on the spot" drawing, and a lot of notes, then I take all the information back to the studio and start work. I tend to use my head when I paint, and to rely on memory.

Charlotte Ardizzone

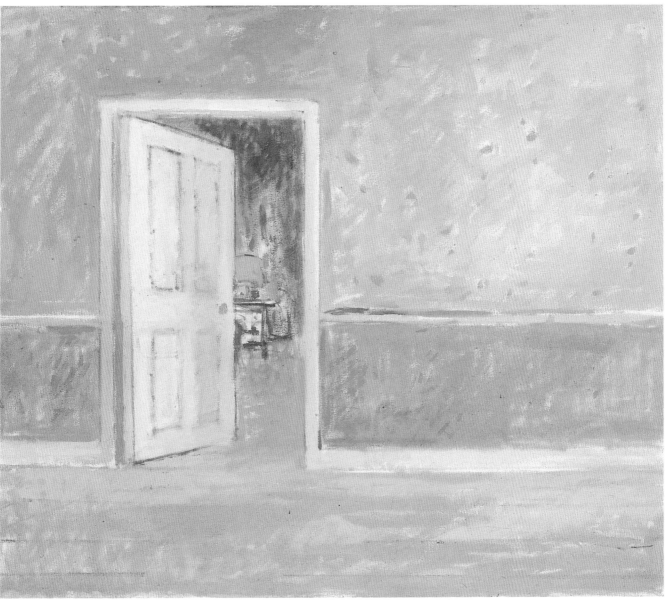

Open Door by Charlotte Ardizzone. Oil on canvas.

46cm×51cm (18in×20in)

Charlotte Ardizzone is primarily concerned with colour; linear definition and detail are almost absent in her work. The composition here is simple, an open door surrounded by a vast area of wall. It is the colour that captivates and holds the viewer's attention.

Two of her favourite colours – Japanese yellow and alizarin crimson – predominate in this interior painting. She also uses a lot of cerulean because it is the basis of so many other "lovely and unusual" colours. Ultramarine and cobalt blue rarely appear on her palette, and she never uses a green from a tube, preferring to mix her own.

As with all Charlotte Ardizonne's work, Open Door was painted directly onto the white primed canvas rather than a coloured or tinted ground. The underlying brightness of the support keeps the colours alive and bright.

The artist began by making a sketchy drawing of the image in diluted cerulean, including just enough information to establish the scale and composition of the painting.

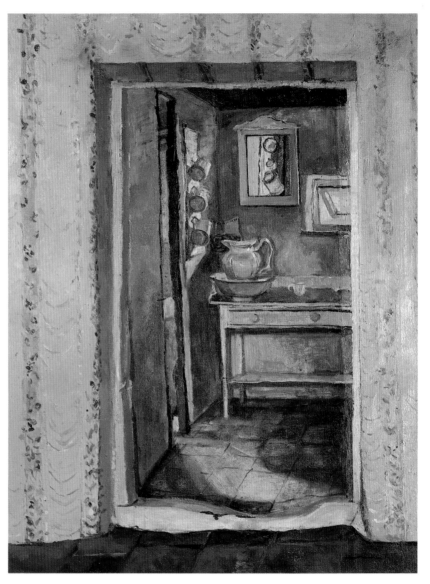

Interior with Mugs by Emily Gwynne-Jones. Oil on canvas. 76cm×51cm(30in×20in)

The "framed view" in this interior is one of
this artist's favourite themes. She also likes
domestic scenes, and to her the atmosphere
of the subject is as important as the tangible
objects in it. This is a painting of a cottage
where she was staying; she was sitting
outside the front door, looking in through
the hall and the kitchen beyond.

Because there was enough time, space and
light available, the painting was done
directly from the subject. Light is very
important in this composition. A bright
hallway opens onto the darker kitchen, and
a shaft of light is thrown across the floor
from an adjoining room.

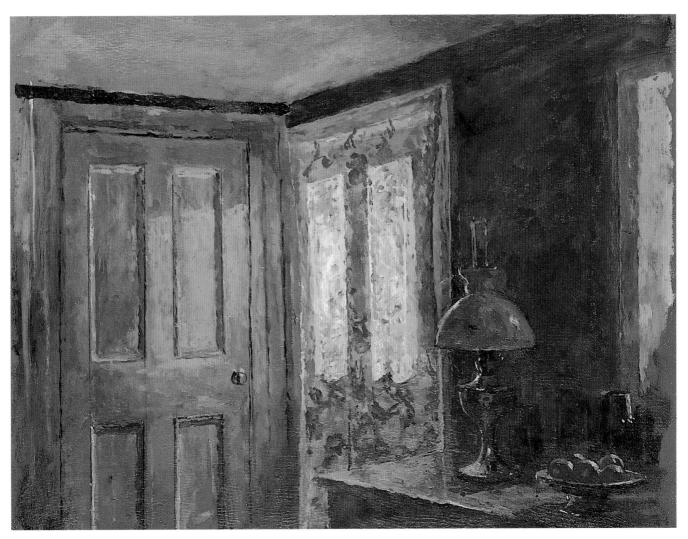

The Lace Curtain by *Fred Dubery. Oil on canvas.* *23cmx41cm (12inx16in)*

"A grey picture with a dash of colour" is how the artist describes this painting. The range of tones – the lights and darks – is the most important aspect. Yet the strikingly bright orange of the fruit is subtly echoed throughout the neutral tones of the composition, lending warmth and harmony to the whole painting. Fred Dubery followed his normal practice of tinting the primed canvas with a flat emulsion ground – in this case with a warm grey. By establishing an overall middle tone in the initial stages, he was able to relate all subsequent lights and darks to this constant tonal value. The lamp and bowl of fruit were already there, exactly as they appear.

An empty room

Wedding Morning, *by Jane Corsellis.*
Oil on canvas. 114cm × 81cm (45in × 32in)

An empty room, cleared in readiness for a wedding reception, captured the artist's imagination. Jane Corsellis feels empty rooms have a marvellous atmosphere, a greater sense of "presence" than rooms which are full of furniture and belongings: "There is always a feeling that someone has just left, or is about to return. A room filled with chairs and clothes is never the same."

The artist made several watercolour sketches before embarking on this oil painting. The object of these studies was to record as much visual information as possible. They were done for reference only and were not intended to be finished paintings. She also made drawings of the subject, with written notes to remind her of the colours and tones; these sketches are especially useful when time is limited or if the painting is to be completed later.

This interior was painted on a beige ground that was tinted by rubbing oil paint into the primed surface. Colours were then built up slowly in thin layers.

The Turkish carpet was particularly layered and worked over with a deliberate lack of detail. To create the broken colour and mottled texture of the carpet, the artist occasionally blotted the wet paint with paper to reveal the colour underneath.

In my paintings I use any method to get the effect I want...this may include blotting, sponging or letting the colour drip onto the canvas...whatever looks right. However, I am a purist where materials are concerned and always use good quality paints and real turpentine. I am also aware of the technical limitations of certain materials and avoid pigments which tend to deteriorate with time.

Jane Corsellis

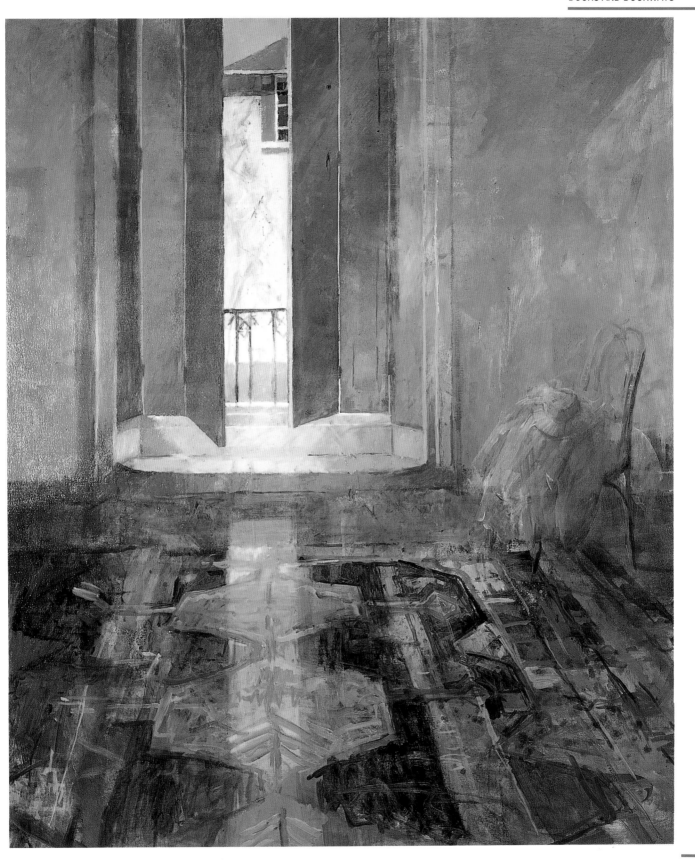

Through the Bedroom Door by Celia Ward. Watercolour. 23cmx30cm (9inx12in)

The "colour" of white is the theme of this painting. Celia Ward was staying in Connecticut, in a typical New England house – very light and simple, and decorated throughout in white. She felt the view through the doorway, of white sheets in a white room, was particularly beautiful; it was a perfect opportunity to study the many colours present in an almost totally white interior.

This bedroom, with the autumn sunlight streaming through the window, is dominated by the strong green of the yew tree outside; the shadows are a cool greenish blue. On the landing, where the artist was working, there was not enough daylight to paint by, so the white walls and door pick up the warmer yellow tones of the electric light.

Prussian blue and raw sienna were used extensively to create the harmonious balance of warm and cool tones. Other colours include burnt umber, raw umber, burnt sienna, ultramarine blue, Hooker's green light and yellow ochre. The paint was generally applied in thin, transparent layers. The artist exploited the white of the paper to represent white and light areas in the picture, although she occasionally worked back into areas, using opaque white gouache to bring out highlights.

Cottage Bedrooms by *Margaret Green.*
Oil on canvas.

46cm×36cm
(18in×14in)

Many of Margaret Green's interior paintings have been inspired by the whitewashed walls and dark stained floors of her cottage. She likes the way the stark black and white set off nearby colours and patterns, emphasizing their brightness and bringing certain objects sharply into focus. In this painting, the artist uses the diminishing scale of the flowered patterns on the fabric and wallpaper to lead the viewer's eye through the open doorways and into the rooms beyond.

To create the roughened, slightly crumbly texture of the cottage walls, Margaret Green mixed powdered titanium white pigment with the white paint. She then painted the wall areas by crushing the thickened, textured oil paint into the canvas with a knife.

The artist describes her approach as "meticulous" and works only when the light is absolutely right.

Sleeping In by Jacqueline Rizvi. Watercolour and body colour. 20cm × 25cm (7in × 10in)

The artist has taken a rare opportunity to paint her daughter while she is asleep. Working partly from drawings, partly from life, Jacqueline Rizvi has used the frame of the bedroom door to define a picture within a picture, a painting of an open doorway that contains a smaller, more intimate composition – that of the sleeping girl.

Jacqueline Rizvi uses an unusual technique, that of combining pure watercolour, which is transparent, with opaque white body colour. Here, for instance, she used an opaque mixture of body colour and watercolour to create the strong pink on the figure; the rich, subtle tones of the wall are built up with strokes of less opaque colour, and with patches of the warm grey paper showing through in certain areas. Although her colours are usually fairly subdued, they are frequently quite complex. She often works from a range of similar tones, in which the variations of colour, though slight, are crucial to the overall effect. Jacqueline Rizvi describes her palette as "elaborate", and likes to have a wide selection of colours to hand as she works. Her general palette consists of 32 "traditional" colours. In this painting she actually used about 16.

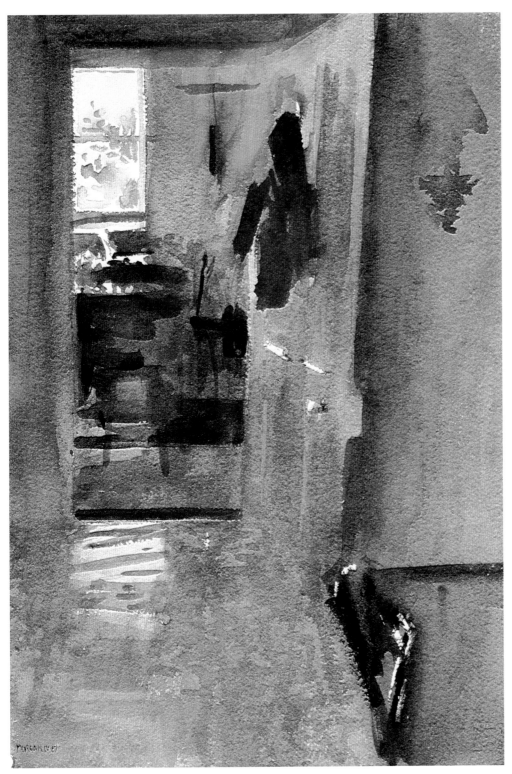

Door to the Dining Room by Howard Morgan. Watercolour. 30cm×18cm (12in×7in)

One of many small studies made by the artist of his home, this view of an open doorway takes the eye down a shadowy hallway and into the airy, light room beyond.

The work was completed in a few minutes. Washes of colour were applied rapidly and loosely on to a sheet of medium weight Arches watercolour paper, patches of this white paper were left unpainted to represent the window and other areas of brilliant sunlight.

Like most of Howard Morgan's watercolour paintings, this interior has a typically lively and spontaneous feel to it – a fresh easiness that is the result of a practised and considered approach. Colour is usually applied quickly but is nevertheless expertly and precisely controlled. Washes of very wet paint are allowed to dry to exactly the right degree of dampness before more colour is applied over them. To achieve these effects quickly, the artist sometimes uses an electric blow drier.

Colours were mixed from his standard watercolour palette of Chinese white, barium yellow, cadmium yellow, raw sienna, scarlet lake, alizarin crimson, cobalt violet, manganese or cerulean, cobalt blue, viridian, ivory black and cadmium orange.

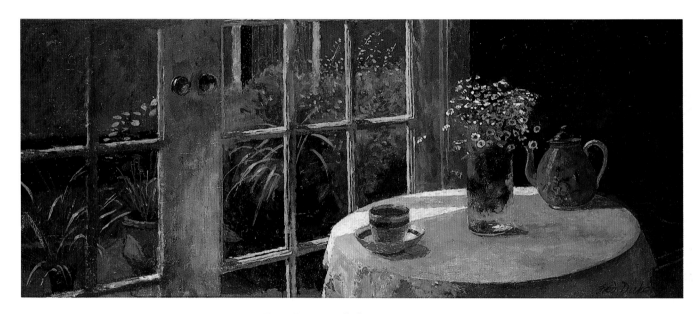

Teatime *by Fred Dubery. Oil on canvas. 23cm×51cm (9in×20in)*

Fred Dubery describes this tranquil and seemingly straightforward composition as something of a "cheat." He stood squarely in front of the subject as he painted the picture; his centre of vision was the centre of the painting. When a subject is viewed from this position, he points out, everything at the edges of the composition becomes distorted – it is a problem that is particularly evident when the artist is working on a large scale or on a very long, horizontal canvas, such as this. The sunlight, for instance, does not really appear in the form of straight, parallel beams; the oval top of the table, which is placed well to the right of the centre of vision, is not really seen as such a perfect ellipse. They are both irregular and distorted, just as they would look if photographed through a wide-angle lens.

In this painting, Fred Dubery sought to correct such optical contradictions by treating each object as if it were in the centre of his field of vision.

4

LIGHT
AND LIGHTING

If only artists could walk into a shop and "buy a tube of light" as the artist Ken Howard has ruefully suggested, then their job would be very simple. But light must be created by the painter, using the materials available.

Interiors can be lit by both natural and artificial light. The light describes the space, the confines of the room, as well as the objects and the people in it. Without a sense of light, there is no feeling of space in a painting, no idea of solidity and form – just flat shapes on a flat surface. Whether the source can be seen, or is suggested, light in a painting must normally be consistent and logical. Fred Dubery originally put together the composition for *Kitchen Conversation*, on pages 78 and 79, from smaller paintings and sketches. When the components were assembled into the larger work he found that the different light sources in the separate references did not correspond, and he had to rectify this. If the lighting is wrong, the painting may be "jarring" to the viewer. This is more true of interiors than any other genre of painting because we all "know" without thinking about it that a room is lit by a definite source, be it a window, door, or electric lamp.

Light helps to describe space. We know nothing about the space behind the artist, but if there is a light source behind him or her, this becomes apparent from the way the light falls on that portion of the room we can see. The light source describes a precisely defined "box" for the objects, figures and artifacts in the interior.

The nature of the light governs how we perceive the subject and also dictates the atmosphere or the mood of the painting. An intense, hard light source – bright sunshine from a specific point, for instance – shows up the subject clearly, producing harshly defined shadows. It tends to make objects look separate and isolated. The opposite is true of diffused and reflected light.

Daylight can change constantly, and this is another factor that governs the painting of interiors. It means that the time of day when the artist can work and the amount of time that can be spent on the painting in any one session are dictated by the movement of the sun and by general atmospheric conditions. Most interiors in which the light comes from the outside have therefore been painted in short spurts over a period of time. Planning these sessions can become central to an artist's routine and approach. Many of the artists featured in this book keep several paintings going at any one time, each depicting the subject at a different time of day. This way, they are able to make the most of the daylight hours.

Oil paint is peculiarly ill-suited to creating the effects of light. It is opaque, and the more the colours are mixed, the duller they will become. As Edmund Fairfax-Lucy points out, mixing white with a colour not only gives you a lighter colour, it also gives you a duller one.

The shape of sunlight

However, the effect of this is overcome by keeping all tones correct in relation to each other so that light still shows up brightly by comparison. Oil painters, therefore, tend to choose a "key" by which every tone can be set. For instance, if every tone is taken down, or darkened by the same amount, the tonal values still remain relative to each other and thus still work within the image.

Because this muddying effect of the pigments works against the illusion of luminosity, the Impressionists, in their quest for light, mixed their colours as little as possible on the palette. They chose instead to place dabs of pure colour side by side on the canvas, allowing them to merge in the viewer's eye. In this way, the brilliance of the unmixed pigments was retained. The Impressionists' idea was to create light with "broken" colour by painting an impression, a "momentary retinal sensation". For many artists, transparent paints, such as watercolour and tempera, come into their own when used to create luminosity and brilliance in a painting.

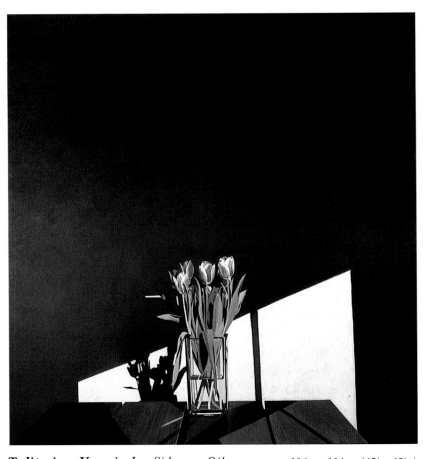

Tulips in a Vase *by Ian Sidaway. Oil on canvas. 114cmx114cm (45inx45in)*

The flat colours and sharp, graphic qualities of this picture are typical of Ian Sidaway's painting. Each element is treated with the same clarity and emphasis. Every form is precisely described as a series of adjoining flat planes, sharply defined areas of light, medium and dark tones. These shapes combine in the eye to describe forms.

Light receives the same graphic treatment. The sunlight is not a filtering, diffused presence, but flat, geometric shapes that are as sharply defined as other elements in the picture.

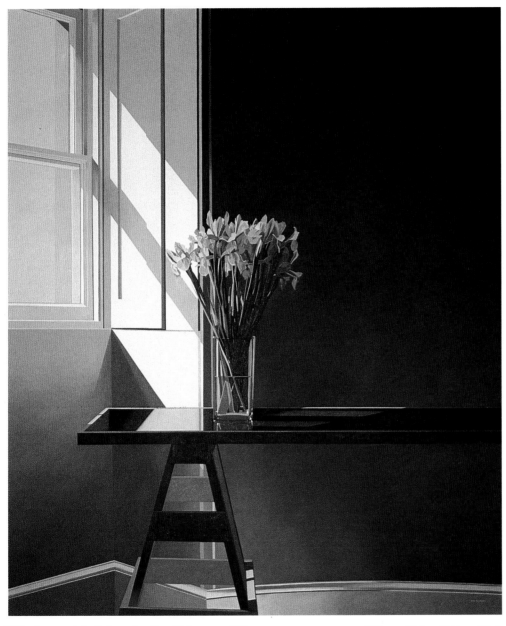

Window with Irises by Ian Sidaway. Oil on canvas. 137cm × 114cm (54in × 45in)

Once I have drawn the subject, I apply colour systematically, one area at a time. With oils, I work across the canvas, painting each area and relating every new tone and colour to its neighbour. Mine is not the tradtional oil painting approach, in which the whole painting is developed at the same time, with the artist continually altering shapes and tones across the canvas. However, once the initial blocking in is complete, I do occasionally work back into the picture, altering any tones and colours which are too strong or too weak in relation to the others. But, ideally, I like to get it right first time.

Ian Sidaway

Sunlight plays an important role in this composition; the diagonal shafts of light lead the viewer's eye into the centre of the painting to the vase of irises, the focal point of the picture.

The composition as a whole is formal and well planned, a considered arrangement of shapes and directional lines. Negative shapes – the empty spaces around the objects – are as vital to the picture as the table, the window and the flowers. Ian Sidaway does not like overcrowded compositions, and he often includes expanses of bare wall in his paintings in order to create a sense of spaciousness. The plain grey background shape in this interior serves this purpose well. It also provides a neutral environment for the more complex, brightly coloured irises.

This painting, like all Ian Sidaway's work, was carefully worked out before any paint was applied. He used a hard pencil to make a detailed line drawing of the subject on the canvas by mapping out the planes of light and shade with precise, clear outlines.

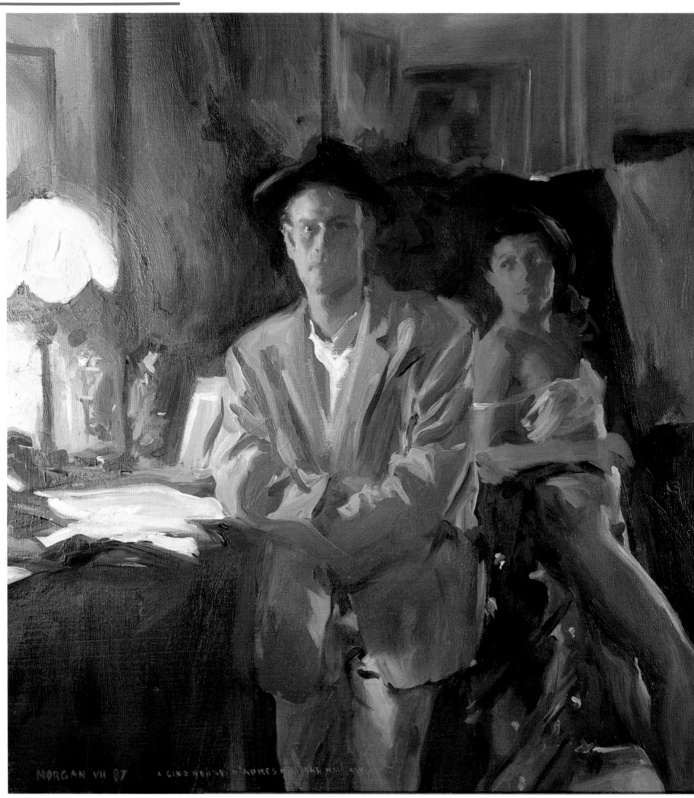

Cinq Heures d'après-midi dans mon Atelier *by Howard Morgan. Oil on canvas.*

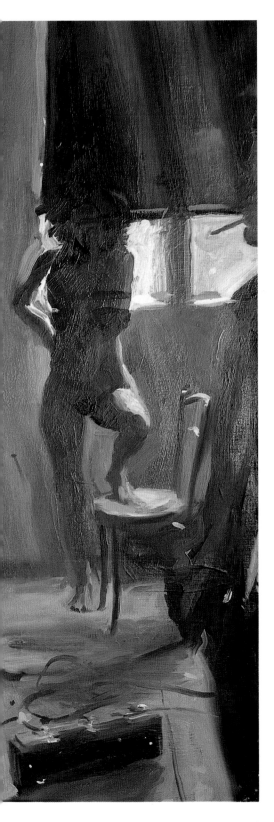

A strange, slightly sinister atmosphere pervades this painting. The man, posing casually for his portrait, is looking directly at the artist, ostentatiously ignoring two semi-naked women who strike erotic attitudes in the background. This disturbing tableau, reminiscent of 1950s film posters, is rather surprising in the context of a contemporary portrait.

The scene, however, is totally contrived. Our nonchalant young man is Howard Morgan's assistant, dressed for the occasion in a black felt hat, and the women are artists' models. The seedy setting is the artist's studio, cleverly lit to create atmosphere and emphasize the man's indifference to his female companions. He stands in the full, dramatic glare of an electric lamp; one woman merges into the gloom behind him; and the second woman is illuminated by a different source – the sunlight streaming through a window at the far end of the room.

71cm×91cm (28in×36in)

Many of my watercolours are done as a sort of self-discipline. I do them because I feel I have to. Most of these take no more than a few minutes. Obviously, a lot of these paintings feature my home, because that is where I spend time, and it is a subject which is always there.

Howard Morgan

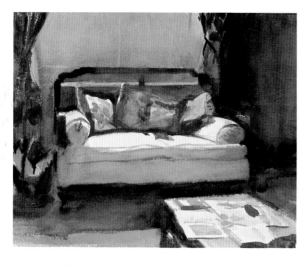

Sofa in the Drawing Room *18cm×30cm (7in×12in) by Howard Morgan.*

Leighton Bannastre *36cm×52cm (14in×21in)*

Both these watercolours (above) were painted during the day, and in both cases, the light is an important aspect of the picture. To capture the effect of sunlight flooding the interior, Howard Morgan has exploited the paper tone, using its cool whiteness to represent thrown patterns of light, reflections and highlights.

For both paintings he used a general palette of Chinese white, barium yellow, cadmium yellow, raw sienna, scarlet lake, alizarin crimson, cobalt violet, manganese blue, cobalt blue, viridian, ivory black and cadmium orange.

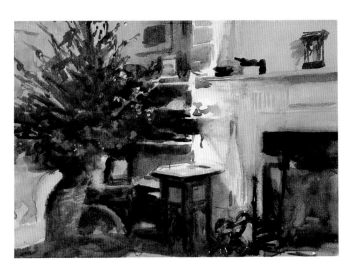

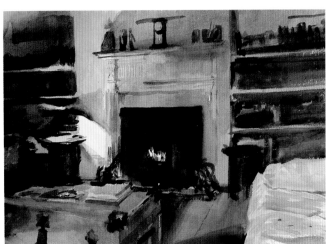

The Christmas Tree *18cm×30cm (7in×12in)*

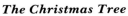

Black Fireplace with Trunk *38cm×58cm (15in×23in)*

*Like the paintings on the opposite page,
these watercolours (above) were inspired by
light. But here the lighting is artificial,
coming from a single source – a warm glow
in* The Christmas Tree, *a colder light in*
Black Fireplace with Trunk. *Again, the
artist has used the tone of the paper, leaving
brilliantly white unpainted areas around the
light sources, and applying very diluted,
transparent washes on the illuminated areas
to cause the light to diffuse outward from
its source. The paintings above and the two
opposite were painted on Arches paper.*

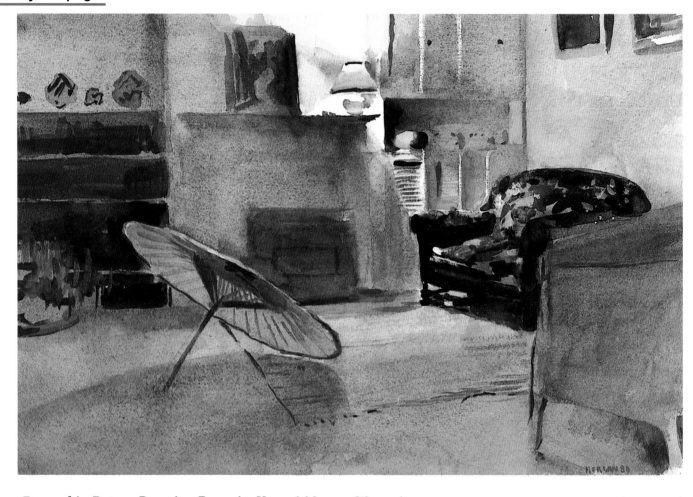

Parasol in Putney Drawing Room by Howard Morgan. Watercolour on paper. *36cm × 51cm (14in × 20in)*

An open parasol is the central feature in this watercolour. The electric lamp on the mantelpiece is the light source, casting strong shadows which the artist uses to connect the objects, to pull together the separate elements in the composition. Howard Morgan is less concerned with the actual objects in his paintings than with their formal qualities. The parasol, for instance, is included here because its shape contributes to the composition, not because the artist likes it as an object.

This is one of many studies made by the artist of his London home. The painting took about two hours – longer than many of his watercolours of similar subjects – and was painted on the back of a "failed" painting.

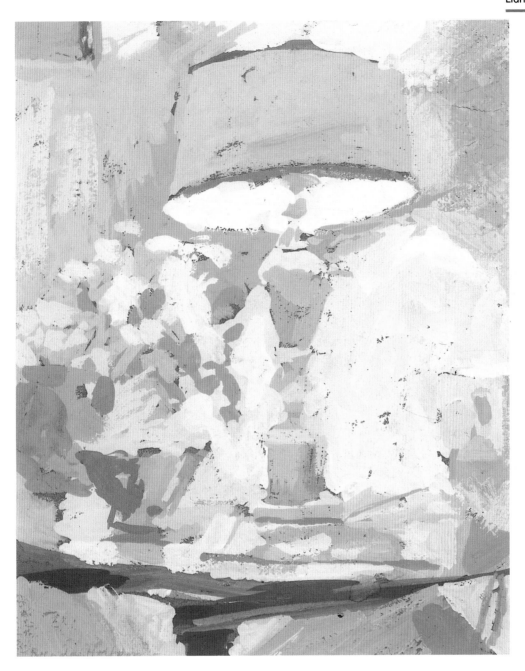

Aldeburgh Table Lamp by Brenda Holtam. Gouache. 13cm×9cm (5in×3½in)

Gouache is one of Brenda Holtam's favourite mediums. She likes the strong, bright colours and the opacity of the paint. She also finds that the colour stays clear, even when several pigments are mixed together. The support for this small painting was a piece of corrugated cardboard cut from an ordinary packing box. Brenda Holtam found this "an ideal material, which has a nice tone, and a wonderfully absorbent surface".

One of the drawbacks of painting with gouache is the tendency of the colours to darken as they dry. For this reason the artist worked quickly, trying to relate the colours and tones before they changed. The painting was completed in one sitting of about two hours.

The bathroom featured in this painting was at the bottom of a flight of stairs, and the artist was intrigued by the bird's eye view of the subject. He made several studies – including this small gouache – all of which were later used as reference for a large oil painting of the same subject.

Stan Smith is an innovative painter who believes in using whatever materials are to hand in order to create a lively, imaginative image. In this study he used candle wax and crayon underneath gouache and watercolour. The wax resisted the water-based paints and produced a broken, rough, scribbled texture that contrasts effectively with the smoother, dense surface of the untextured paint.

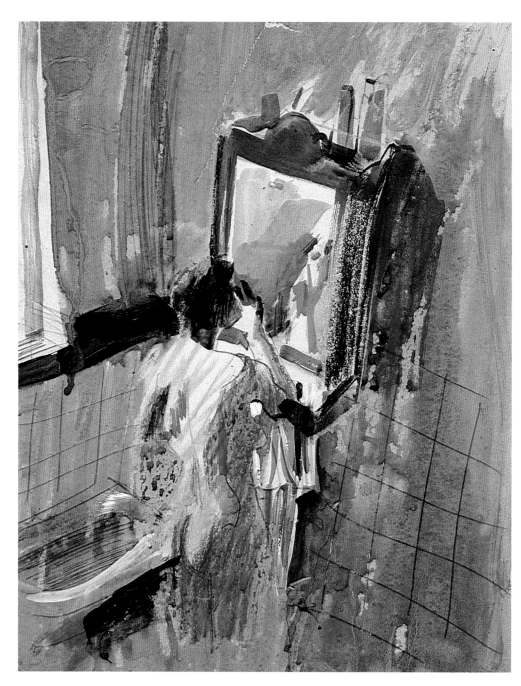

Steam, Rain and Colour by Stan Smith. Mixed media on paper. 20cm×15cm (8in×6in)

5

SHADOWS AND REFLECTIONS

The variety of shadows and reflections found in the enclosed space of a room presents both problems and opportunities for the artist. Reflections and shadows can add interest, depth and dimension, but they can also obscure, complicate and occasionally even contradict the light source of the subject. The shadows and reflections in a room dictate the mood and atmosphere of the painting. Their strength and colour indicate the time of day and can actually convey an impression of temperature – of heat or chill – in a room.

Shadows and reflections play an important part in all the paintings here. In each case, they are as crucial to the finished result as the tangible objects.

Our homes are filled with reflections – something which many of us take for granted in a society where glass, mirrors and mechanically shiny surfaces are abundant. We "know" what is real and what is reflected, so we rarely confuse an object with its reflected image. In fact, we are so accustomed to reflections that we tend to ignore them. Thus the painted reflection sometimes comes as a shock. We see how strong and definite a reflection can actually be. In fact, the reflection of an object on a shiny surface is frequently as visually strong and clear as the object itself.

In some interior scenes, mirrored reflections play tricks with the light; they can make a room seem larger than it actually is and they can also show the viewer what is behind the artist.

One of the prime opportunities offered by mirrors, is the chance to show two sides of the same subject. In Stan Smith's painting on the opposite page, the nude is looking into the bathroom mirror. We see the woman from the back, but we also see her face in the mirror. It is not a detailed face, just a suggestion, but it is enough to give her an identity. The painting therefore becomes more personal, less academic. A sense of the person is added.

When an artist paints a mirror, it often describes the lighting conditions in the whole room. Depending on the position of the window or lamp, lighting can change considerably from one side of a room to another. We expect this and often do not notice the subtle gradation from light to dark. But a mirror reflects the light on the opposite side of the room. Thus a mirror on a shadowy wall is often represented as a slab of light tone. In comparison a mirror on a

The shapes of shadows

brightly lit wall, reflecting the darkness opposite, may appear very dark. For this reason, a mirror can be more noticeable in a painting than real life.

The mirror has been portrayed in paintings for centuries. Its most obvious use is in the self-portrait, when the artist paints his or her own image as seen in the mirror. But these ultimate reflectors of light have played more unusual roles. Van Eyck's painting of the Arnolfini wedding, at which the artist is generally supposed to have been a witness, includes his reflection and that of a second witness in the mirror at the back of the room.

In some paintings a spotless mirror is symbolic of purity. In others it can reinforce the subject, giving a suggestion of beauty, or vanity, or both. The beauty of Venus is suggested as well as portrayed literally in Velazquez's *Rokeby Venus*, in which a woman admires herself in a mirror held by Cupid.

Niel Bally's paintings on pages 58 and 59 are all about reflections and shadows. Light moving around the objects, the surface textures and irregularities – these are revealed through shadow and light. Here, the reflected images are actually stronger, more emphatic, than the vessels being reflected. These paintings are not really about vases and bowls on a table but have become statements about physical matter, about reflective and non-reflective substances. They depend on light – on reflection and shadow – for their existence as recognizable objects.

In some paintings the main role of shadows is to show the strength and type of light. In others, they appear hard and strong, becoming just as important in the overall composition as the objects that throw them. Surrealist paintings frequently contain unnaturally sharp shadows that indicate an unreal light and create an unearthly atmosphere. Depending on the light, or the way the artist chooses to use them, shadows can play a dominant role in a painting. Sometimes, however, their role is incidental, or even non-existent. Naïve and primitive paintings, for instance, often contain stylized shadows or no shadows at all.

This was not an easy subject. The strong directional light and the dark, elongated shadows were attractive to Howard Morgan, but they also presented a challenge. The painting was done a few years ago and, looking at it now, the artist is not sure he was entirely successful – mainly because he started with shadow and then tried to establish the light source.

"The changing light was a problem, but I had a go," he says. "Anyway, when you take on something like this, nature will beat you hands down every time!"

The painting was completed in about ten minutes, with colours selected from a palette of Chinese white, barium yellow, cadmium yellow, raw sienna, scarlet lake, alizarin crimson, cobalt violet, cerulean, cobalt blue, viridian, ivory black and cadmium orange.

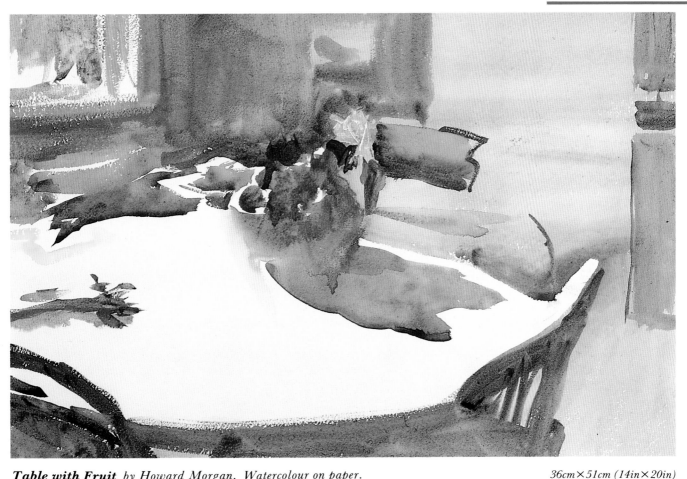

Table with Fruit by Howard Morgan. Watercolour on paper. 36cm×51cm (14in×20in)

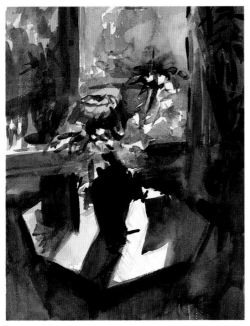

A potted plant and other objects throw deep shadows across the surface of a polished table (left). The light is natural and was therefore constantly changing. As with the painting opposite, the artist had to work very quickly in order to capture the dramatic atmosphere of this subject before the tones and colours were altered completely. The work took no more than ten minutes.

To help speed up the process, the artist sometimes employs an electric blow heater. The drier also helps him to retain control over what can be a very random and unpredictable medium.

Octagonal Table by Howard Morgan.
Watercolour on paper. 18cm×30cm (7in×12in)

Two still-lifes

I use the subject as a starting point... the motif itself becomes a vehicle from which I develop the final image. Mass, areas of colour, and a fresh, spontaneous application of paint become all-important as the picture progresses. I usually aim to create a painting which exists in its own right, independent of its objective source".

Niel Bally

Still-life; Mexico *by Niel Bally. Oil on canvas.* *81cm×91cm (32in×36in)*

Movement is an important aspect of this seemingly static arrangement of objects. Niel Bally is fascinated by the effect of moving light, by the way it is reflected off surfaces and by the way in which the surface itself can affect the nature of the reflection. For instance, the reflections in this painting were fragmented by the uneven nature of the tabletop.

The artist also introduces movement into his painting by constantly shifting his viewpoint. When he was working on this composition, he moved around the subject every few hours; thus, the final image was arrived at from a number of different angles. This painting, he says, has more to do with the act of looking than with the actual objects, and "looking is seldom a static experience."

Compositionally, this painting is neither abstract nor completely figurative. Niel Bally was aiming at something between the two. He describes the picture as "being primariy concerned with creating light and space from flat, two-dimensional marks of broken paint." Space, he says, was created by means of a "paint veil," built up with a variety of techniques that included scumbling, glazing and overpainting, and by establishing areas of opaque colour. He was aware that the paint marks had to be of equal strength so that no one mark would overpower the others and create an unwanted "opening" in what was intended to be a two-dimensional image.

The painting was done on a medium-grey acrylic ground, using a wide selection of colours – Van Dyke brown, brown madder, burnt umber, alizarin crimson, magenta, violet, Prussian blue, cerulean, ultramarine blue, sap green, phthalo green, vermilion, Venetian red, Indian yellow, cadmium yellow, lemon yellow, lamp black and ivory black. The artist used a drying medium.

Green Spotted Bowl *by Niel Bally. Oil and encaustic on canvas. 83cm×96cm (33in×38in)*

Niel Bally painted this considered still-life arrangement a few months after returning to Europe from Mexico. The painting was, he says, a direct response to the change of light. In Mexico the light was intense, producing strong contrasts. European light, in comparison, seemed very much softer, a muted grey.

The arrangement of the subject was particularly important here. Because the artist was primarily concerned with light and colour, he spent some time arranging the objects on the table, paying particular attention to the light source and the shadows it produced. He moved the objects around, making several preliminary studies before deciding on the final arrangement.

Green Spotted Bowl *is not an objective painting. Niel Bally used the subject as a starting point, a vehicle for his own impressions. His aim was to capture the initial, fleeting sensation of colour and light rather than to produce a strictly representational image. Once the subject was established, the artist felt free to change this basic motif, altering the image to make it work pictorially, if not literally.*

This still-life was completed in two afternoon sessions. Paint was used both transparently and opaquely. Occasionally the artist dragged or scumbled colour onto the canvas, allowing the underpainting to show through. He also used encaustic – a medium mixed from turpentine and beeswax – mixing this with the paint to make the colours more translucent. This process also speeded up the drying time of the oil paint, allowing areas to be worked over within a few hours.

Niel Bally worked from a palette of ivory black, Indian yellow, Van Dyke brown, madder brown, alizarin crimson, Prussian blue, cerulean, ultramarine blue, Venetian red and titanium white.

This interior is one of a series – three large canvases, all of them painted between 7am and 10am over a period of several days at the artist's home in Cornwall. Thanks to a well-planned work schedule, he was able to work on each painting for an hour every morning in order to capture the early sunlight. In order to establish the light more precisely, he made a large preliminary working drawing for each painting.

Although this painting shows the back of the subject's head, the artist feels it is the best likeness he has achieved of this particular model. This, he says, is because likeness has more to do with overall position – how a person moves, sits and stands – than with specific detail or facial features.

Despite the various blue tones in the painting, Ken Howard had no blue on his palette. The blue tones in the painting were mixed from white and blue black. The surrounding warm tones – burnt sienna, raw sienna and yellow ochre – make this bluish grey seem much bluer than it is.

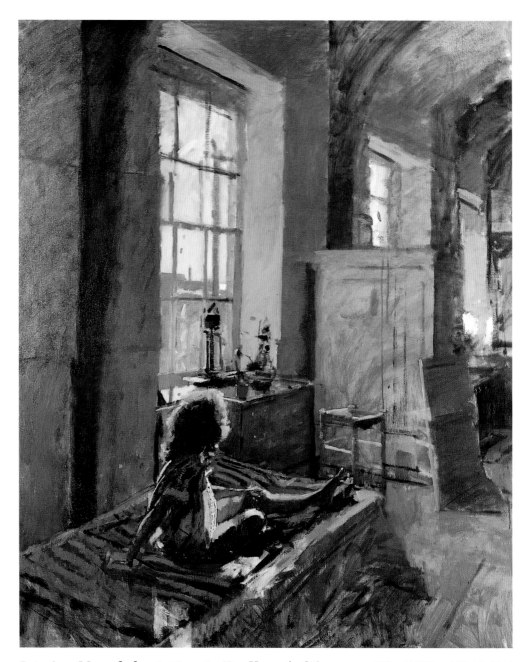

Interior: Mousehole; 8.40am by Ken Howard. Oil. *102cm×123 cm (40in× 48in)*

6

THE FIGURE INDOORS

The history of painting, particularly Western painting, is largely the history of depicting the human form. Whether surrounded by the trappings of religion, warfare, landscape, or domesticity the figure is almost always the focal point; and one of the most common themes in art history is the human form in an interior setting.

The painted figure invariably takes priority. The interior – the context – is secondary. Yet, except in a minority of studies – including anatomical ones - figures are always depicted in an environment of some kind, an environment that cannot help but tell a story.

As soon as it is placed in a room the figure becomes the focal point of that room – just as the eyes are the focal point of the face. But the environment will often underscore what the figure is doing. An image of a person washing dishes, for instance might be strengthened by the crockery, the sink and the surrounding kitchen.

Two or more figures are powerful components in any interior painting. The way in which these figures relate within the composition affects the whole work. If they are facing each other, aware of each other's existence, the interior inevitably looks harmonious, inhabited. Figures turned away from each other, especially if they are looking towards the edge of the picture, compete to take the viewer's eye in opposite, outward directions. The enclosed interior composition is contradicted and destroyed. The scene becomes disjointed and uncomfortable.

Pictorially, the figure is linked to its environment by tone and colour. Bernard Dunstan's nudes, two of which are illustrated here, are painted in such a way that the light and colours of the room are diffused and echoed in the flesh tones, and vice versa. The figures seem to be organically connected to the rooms they are standing in. Stan Smith's figure is bathed in light; bars of light and shadow from the window blinds are used to describe the figure. In Ken Howard's studio interiors, the light is expressed by the tonal relationships between the figure and its surroundings. All the dancers in Alan Halliday's drawings move within the confines of a studio. In these artists' works there is an important and specific relationship between the figure and the room that makes the room much more than a mere backdrop.

"You can paint the same figure in the same place many, many times without the paintings becoming repetitive or boring," says one artist, who frequently uses his wife as a model. "The figure and the room will be different every time, depending on the light and where the artist is standing. Nothing is the same every time."

Many commissioned portraits show the subject sitting in an interior, usually a room that has a special meaning for the sitter. Most people want to be seen in their own environment; portrayed against a room in their own house, surrounded by their own belongings. This idea recalls the "conversation piece," a genre of painting popular in

the eighteenth century in which people – usually a married couple or a family group – were depicted in their own environment – often domestic. The familiar surroundings give a special meaning to the people, who cease to be anonymous figures. Margaret Green, who painted her mother and niece in their kitchen (opposite), says that nothing would induce her to part with the painting. The setting was her mother's house, and the picture therefore has a special meaning for her.

Apart from works done for architectural or topographical purposes, the practice of painting interiors without figures is comparatively recent. It is the human influence or the implied human presence that brings the pictures to life. Rather like a stage set where the actors have not yet turned up, the interior without figures is waiting for its rightful occupants to return.

In the late nineteenth and twentieth centuries, the absence of rigid genres encouraged a more informal approach to subject matter. The figure in the interior was accessible and available to artists – most of whom no longer had rich patrons and organizations to please, but the majority of whom had homes, relatives and friends to paint.

It is not only in art that barriers have been broken down. There is also an inter-disciplinary crossing of boundaries, in which painters, economists, sociologists, and people in all walks of life have found mutual interests and common ground. For some artists, this has resulted in a tendency to create paintings that are more socially meaningful, a trend toward statements about the "human condition" and a rejection of any suggestion of blandness or sentimentality in painting. In such a context, paintings of the figure in an interior have already moved away from their traditional position of being merely a vehicle for the artist's self expression, and have become opinionated observations about society.

The figures in this picture represent both the generation before and the generation after the artist. They are her mother and niece, painted from life over a period of a few days. Margaret Green asked them to pose from time to time for short sessions. The result is a fresh, living image. It is not a rendering of two models holding a fixed position but a painting of two very real people at work in a real, living environment.

The headscarf and overall add an interesting nostalgic touch. Washing Up was painted several years ago, and Margaret Green is now better known as a landscape artist. Looking back at some of her earlier work, she expresses some regret at not having done more interior and figure paintings in recent years, and feels she would like to return to these neglected subjects.

The colours used in this painting included black, white, yellow ochre, light red, cadmium yellow, raw umber, ultramarine blue, golden ochre, crimson and cadmium red. Nowadays, Margaret Green says, she is less scrupulous than before about sticking to well-tried, traditional pigments and is much more inclined to try out new colours.

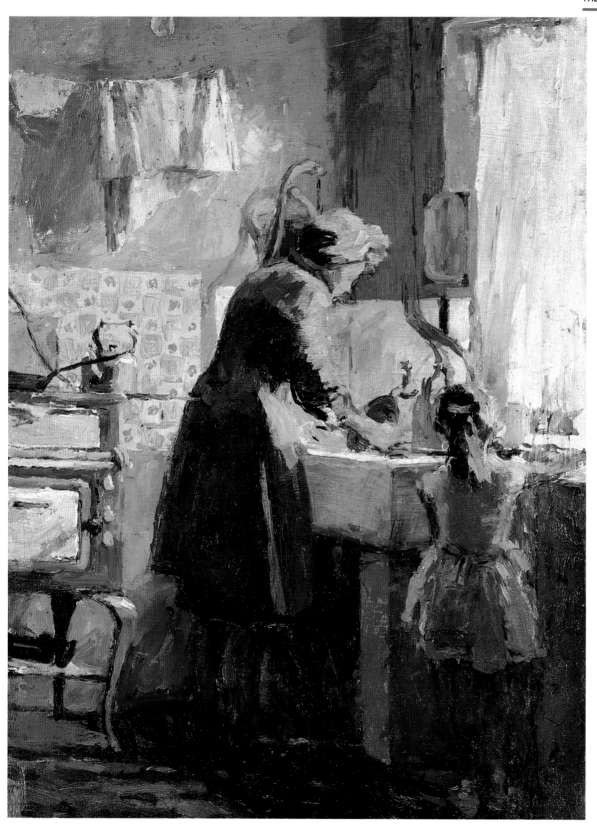

Washing Up *by Margaret Green. Oil on cardboard.* *36cm×23cm (14in×9in)*

This small interior (right) was painted largely from memory and imagination. Brenda Holtam's working sketch (above) recorded the overall tones and general composition, but it gave no indication of local colour. Later, when the subject was no longer in front of her, she reconstructed the scene from what she could remember, keeping the colours as general as possible.

Brenda Holtam used a 2B pencil for the small preliminary sketchbook drawing. The combination of shapes and light first attracted the artist to this subject – a response that is reflected in the fine lines and careful tone of the drawing.

For the painting she used a neutral ground mixed from raw umber and burnt sienna. This warm tone was allowed to show through in places; in some places it is used to indicate shadows. The artist's palette consisted of yellow ochre, burnt sienna, black, white, raw sienna, raw umber, alizarin crimson, light red, phthalo blue and white.

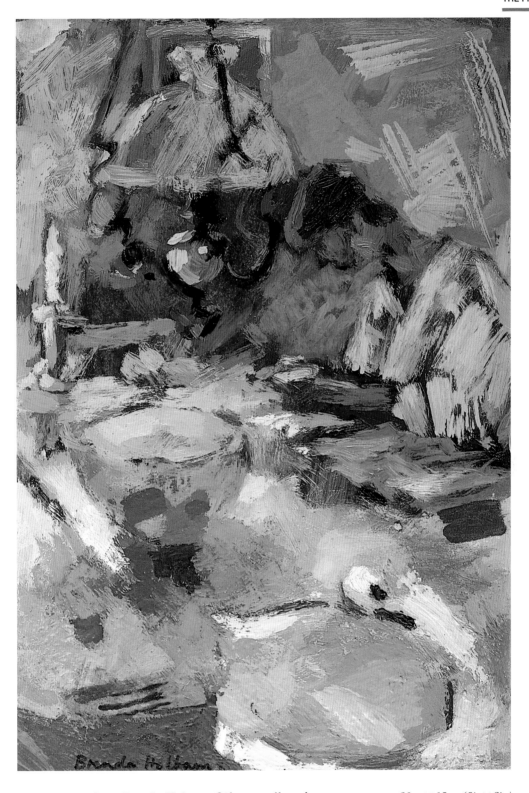

Sue at Work *by Brenda Holtam. Oil on cardboard.* *20cm×15cm (8in×6in)*

The figure trapped in light

The model sits in front of the window, the sun streaming through the Venetian blinds. Strong, linear shadows from the slats of the blinds are thrown across the figure, thus providing the artist with an accurate description of the contours and form. The effect, he says, would be the same if she were wearing a striped costume.

A fascination with the notion of the figure "trapped" in light is a recurring theme in Stan Smith's work. It is, he says, a way of seeing and understanding the subject. For this artist, the shadow patterns on the model are not merely an interesting, superficial effect, but they are there to describe the form underneath – the structure of the human figure. This system calls for rigorous analysis of the subject – it is not enough simply to copy the stripes – and Stan Smith's extensive knowledge of anatomy is essential to his success with this approach.

All the drawings were made within an hour of each other, the idea being to record the movement of the sunlight in the room within that short space of time. They were not done with a specific painting in mind, although the drawings contain enough information to develop the idea at a later date. Stan Smith felt it was important to work quickly in order to convey a sense of energy and movement in the sketches – a quality he always tries to retain when enlarging drawings on to a bigger canvas.

Light on the Seated Figure *by Stan Smith. Sketchbook and pencil.*

15cm×10cm (6in×4in)

I feel it is a bad idea to spend too long over figure sketches. One can quickly pick up enough information to develop into a painting ... a slow, laborious drawing rarely has the vibrancy and tension of a rapid sketch. And with short poses, it is possible for the model to hold positions for longer.

Stan Smith

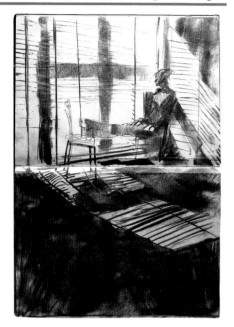

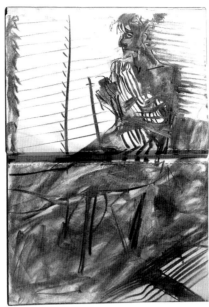

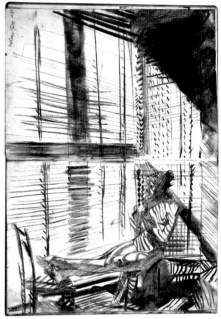

Stan Smith made no fewer than 30 drawings of this subject. The model, a ballet dancer, held this regal yet difficult pose for limited periods over three days. During that time the artist worked in pen and ink, chalk and ball-point pen, as well as the Conté, pencil and charcoal featured above. His aim was to capture the calm atmosphere of the room and the dignity of the dancer sitting in the light from the window.

At the time, the artist did not intend to make a painting from these drawings, although he later went on to produce a large oil composition (right). Initially, he used the drawings as the basis for the oil painting, placing the figure low on the canvas. This was not successful: the model, he says, looked as though she had been "hammered" to the bottom of the picture. His solution was to move the figure to the top of the painting, making the composition look lighter and more spacious.

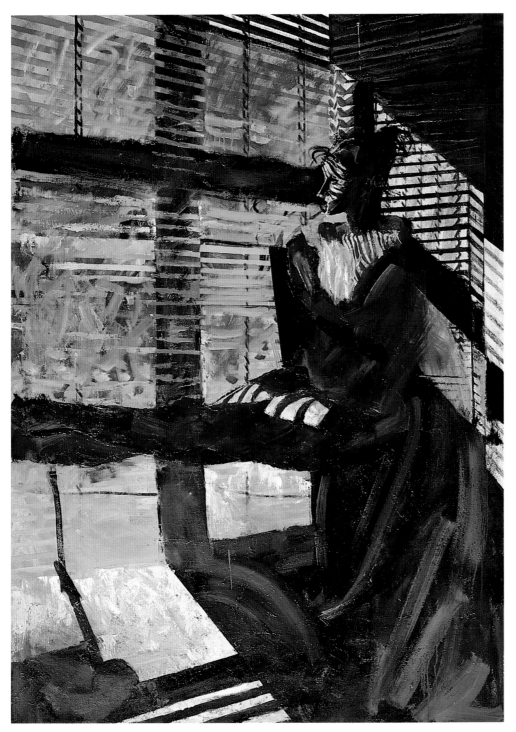

I like to keep my paintings on the move, in a constant state of flux...I rarely regard a work as "finished"... a painting can always be reconsidered, even after months or, sometimes, years. The most important thing is to keep the image alive and vital. Quick sketches often have a sense of energy and movement which a finished drawing can lack. But it is dificult to retain this vitality when transferring the image onto a larger canvas. I usually work directly onto the canvas with the minimum of drawing – sometimes none at all.

Stan Smith

Dance of Light by Stan Smith. Oil on canvas. 213cm×152cm (84in×60in)

This is a painting about light, but, as Ken Howard points out, it is not possible to go out and buy a tube of light. Artists have to create their own, by carefully interpreting the tones and colours within the subject.

The artist deliberately chose the back view of the model. He wanted the painting to be about light and the figure in the interior, not about the female form. In this case, the artist felt it was important to establish the correct tonal relationship between the figure and the white wall behind her – although, as Ken Howard points out, the wall in the painting is far from white.

The painting was completed in a single five hour session. The artist was teaching at the time and felt the students could learn from watching him.

Ken Howard worked from his usual "earth" palette of black, white, raw umber, yellow ochre, raw sienna and Indian red.

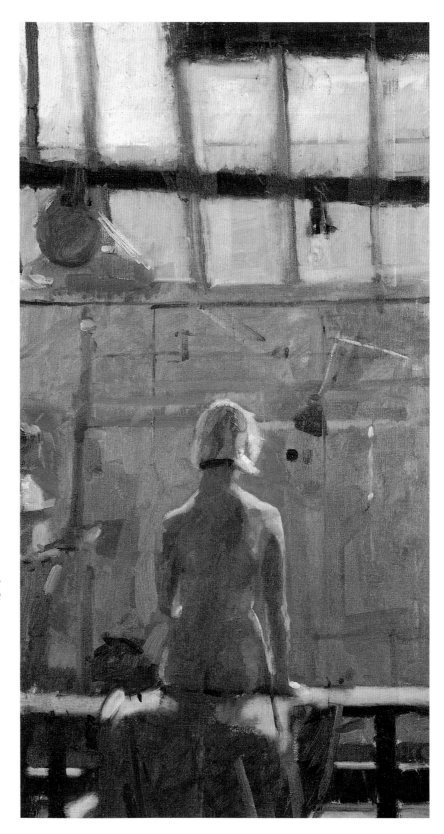

Life Room at the Academy by Ken Howard. *76cm×41cm (30in×16in)*

M

y paintings are about light. Whatever the subject, it is the effect of the light on that subject that interests me most.

Ken Howard

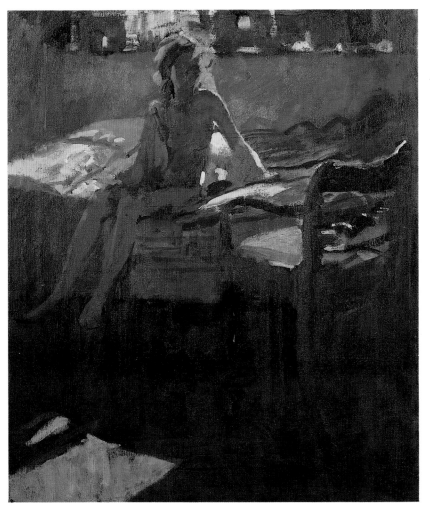

Valerie in Silk Shirt by Ken Howard. Oil on canvas.

61cm×51cm (24in×20in)

Ken Howard's interiors are almost always painted with the same "earth" palette of black, white, raw umber, yellow ochre, raw sienna and Indian red. He usually introduces one other colour to his normal selection, always a colour that appears in the subject. This is then mixed with others on the palette and becomes a unifying theme in the composition. Here the "guest" colour was red, chosen because of the red on the model's scarf.

As with most of the artist's work, this interior is concerned primarily with light. The model is wearing a silk skirt, diliberately chosen because of the way the translucent fabric filters the light. Ken Howard says the painting was inspired by one of his favourite English artists, Sickert. When he saw the model sitting by the window he was reminded of the many "marvellous" interiors of that artist and other members of the Camden Town Group.

Diana in Limoux by Bernard Dunstan.
Oil on muslin-covered board.
36cm×25cm (14in×10in)

When Bernard Dunstan goes on a painting trip, he takes with him a stack of small supports, primed and tinted and ready to paint on. The sizes and proportions vary slightly, and the coloured grounds include muted greens, violets and pinks – "never anything very powerful." Although his choice of ground is instinctive – sometimes it echoes the colours in the subject, sometimes it complements them – his supply almost always includes a suitable canvas for any subject he might care to paint. Diana in Limoux *was painted in a hotel bedroom during one of the artist's many visits to France.*

Bernard Dunstan always makes his own supports by stretching muslin or linen over board, usually hardboard. This is then primed with an egg-oil emulsion, which he prepares himself. His recipe is traditional – a whole egg mixed with the same amount of oil and twice the amount of water. The oil and water are measured in the broken halves of the eggshell to ensure absolute accuracy. This emulsion is thickened to a stiff paste with powdered titanium white pigment, then diluted to the required consistency with a solution of glue size. The strength of the size dictates the absorbency of the painting surface – the stronger the size, the less absorbent the support.

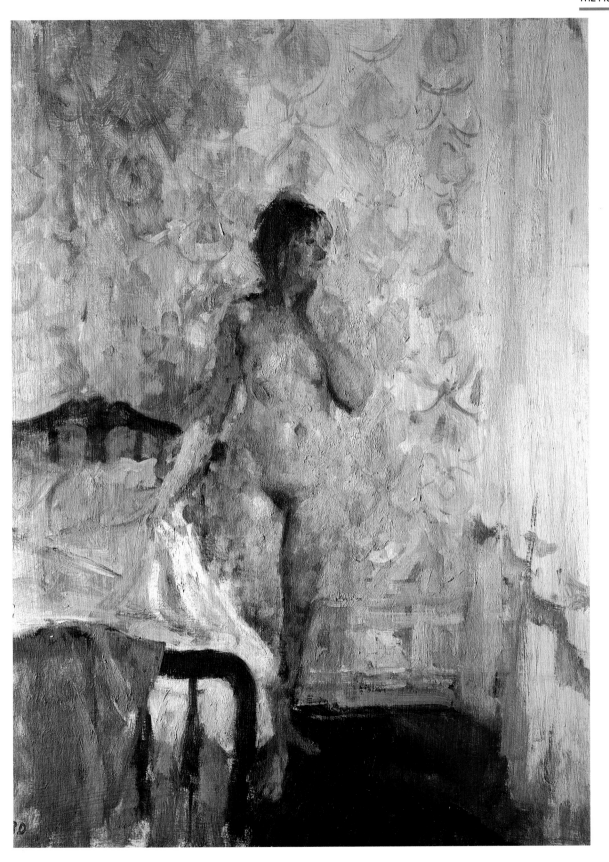

Light on the figure

For me, it is always much easier to start a new painting than it is to finish one I am already working on. I usually have lots of pictures going at any one time – sometimes as many as twelve – and I like to keep going back to them again and again. Often, I only finish a painting if I really have to – when other people are getting impatient or when someone is waiting to take it away!

Bernard Dunstan

The nude standing by a window in a sunlit room is one of Bernard Dunstan's most often-used subjects. He frequently makes drawings prior to painting (left), and occasionally he takes colour notes for reference. If time is limited, he usually draws the subject directly onto the support and touches in spots of observed colour across the image. These colour dabs set the key for the composition, and he is then able to take the painting away and finish it at a later date.

Bernard Dunstan prefers to keep his painting process as simple as possible, applying warm and cool tones in brushstrokes of broken colour across the whole image. He works from a palette of flake white, yellow ochre, raw sienna, cadmium yellow, cadmium red, alizarin crimson, burnt sienna, raw umber, burnt umber, cobalt violet, cerulean, ultramarine blue, viridian, and black.

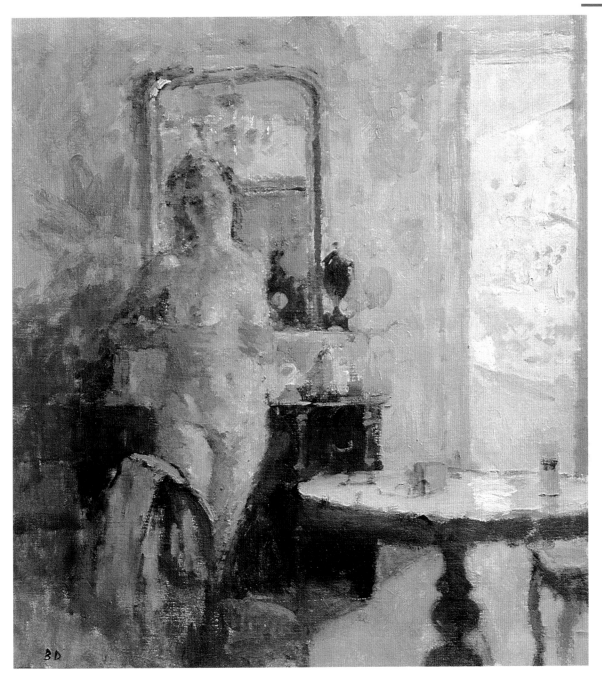

The Bedroom by Bernard Dunstan. Oil on muslin-covered board. *36cm×25cm (14in×10in)*

Figures in motion

The Sadlers Wells Studio at The Royal Ballet School *by Alan Halliday. Ink on paper.* *25cm×18cm (10in×7in)*

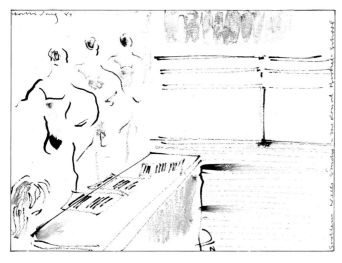

Alan Halliday has always been fascinated by ballet and by the idea of figures moving in space. He has spent many hours at this ballet school, observing the students dancing and practising their routines.

Speed was essential for these drawings; the artist worked quickly to capture rapidly changing positions and to trace steps and dance sequences within the space of the surrounding studio. Reflections, both in the studio mirrors and on the polished wooden floor, helped him to establish the position of each dancer within the defined space of the ballet studio.

The drawings contain no extraneous or irrelevant detail. Alan Halliday has conveyed the essence of his subject by economical use of line and tone – a disciplined approach that ensures a lively, spontaneous result. He worked in ink, drawing with a Japanese bamboo pen. Washes of tone – used mainly to establish the reflections – were added with a sable brush. All the drawings were completed on the spot, and the artist did nothing more to them after leaving the dance studio.

Composition with figures

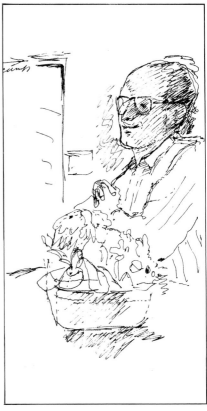

These delightful pen and ink sketches were made on the backs of envelopes – in the Dubery kitchen during a friend's visit. Such sketches are essential to the artist's work. Fred Dubery went on to combine the separate elements of the sketches in a painting (opposite), choosing to include the figures and flowers in one composition rather than make them into separate paintings.

Fred Dubery cannot work from photographs: "They give you far too much information, and most of it is irrelevant." Drawings allow him to record the things it is difficult to remember, such as specific details, shape and scale.

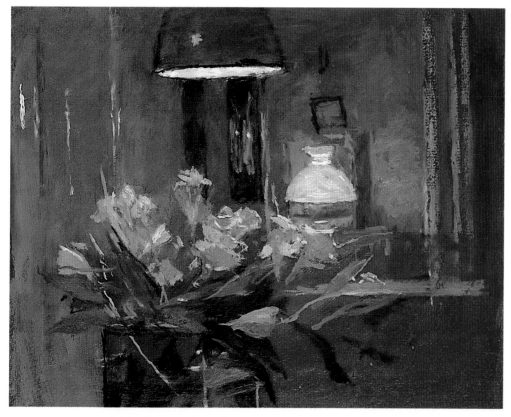

These paintings (left and below left) were developed from the drawings on the opposite page. Instead of using them for two paintings – which he may still do – Fred Dubery incorporated them into a more complex composition. Inspired by an unfinished portrait, he also decided to include his wife.

Working from the separate paintings of his wife and his friends, the artist put the two figures together in a new, larger composition. This was not immediately successful. As Fred Dubery explains, the light sources in the original paintings were completely different – his friend's portrait was lit from above; in the painting of his wife, the light came from behind. When the two were combined, the image looked

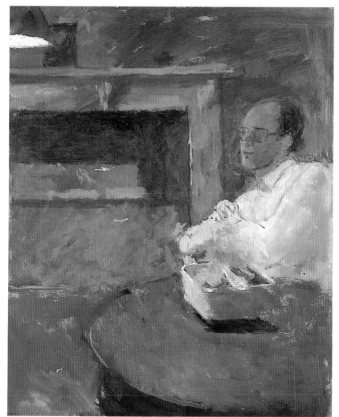

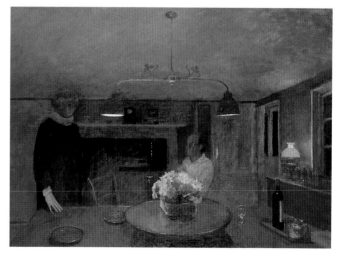

Kitchen Conversation
by Fred Dubery. Oil on canvas.
60cm×97cm (24in×38in)

unconvincing.

Once these lighting problems had been resolved, the artist went on to develop the painting. He was, he says, particularly interested in the idea of dividing the light between a "full" light and a "half" light – an effect he achieves in the finished painting (below).

Painting children

The artist realized that his six-year-old son was not going to stand still for very long, so he worked quickly, completing this large painting in half an hour.

To save time, Stan Smith dispensed with an initial drawing, establishing the subject straight away with blocks of colour – a loose combination of opaque gouache and transparent watercolour washes. Darker tones and shading were then scribbled in with graphite pencil. Finally, the artist used dip pen and pencil to define the form and to add selected details.

With Jasper, speed was essential, but Stan Smith feels there are other good reasons for working quickly: an enforced time limit encourages the artist to think of new techniques and to develop a visual shorthand; the experience can be both a stimulating and rewarding one.

Jasper by Stan Smith. Mixed media on paper. 51cm×76cm (20in×30in)

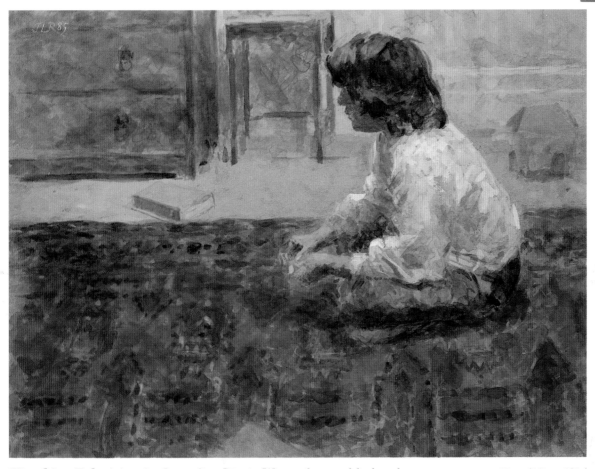

Watching Television by Jacqueline Rizvi. Watercolour and body colour.　　25cm×33cm (10in×13in)

The delicate, silky surface of the Japanese rice paper used for this painting required careful handling. Although it is one of Jacqueline Rizvi's favourite supports, it is also very delicate. For instance, the artist could not apply any pressure, as this would have caused the paper to crinkle. She was, however, able to overlay colours providing she worked carefully.

One of the aspects of the scene that appealed to her most was the relationship of the figure to the richly patterned carpet – a contrast that is brought out well by Jacqueline Rizvi's technique of building up the image with small strokes of overlaid colour.

A friend once accused Edmund Fairfax-Lucy of choosing only classically beautiful subjects to paint. He responded with this painting of an interior that includes silver candlesticks and a television set. More seriously, he says the subject appealed to him mainly because of the strong winter sunlight and the haze it created in the room.

He describes his approach as "schematic" and starts each painting with a very definite plan. For instance, he will choose one grey for use on the near objects and a different grey mixture for a similar colour seen in the distance. This helps describe the space by differentiating between background and foreground.

As with all his pictures, the artist painted Silver Candlesticks *directly from life – he never paints from drawings.*

His palette consists of about twelve colours, although he normally only uses about seven of these in any one composition. The general palette includes titanium white; lamp black (of which he uses a lot); yellow ochre; always, either viridian, terre verte or oxide of chromium; a blue, often ultramarine; light red; rose madder; cadmium yellow deep; vermilion; and lemon yellow.

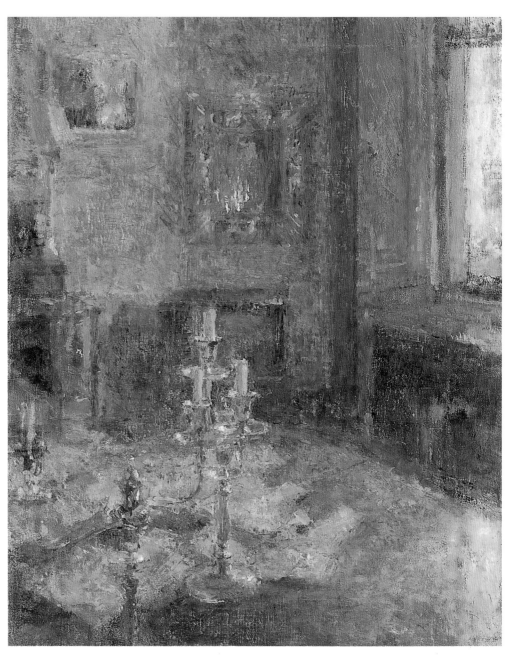

Silver Candlesticks by Edmund Fairfax-Lucy. Oil on canvas. 43cm×33cm (17in×13in)

7
FORMAL INTERIORS

The paintings in this section are of people's homes, but a different type of home than many of those illustrated earlier. These are not the cosy dwellings of one person, or a family, stamped with the taste of one or two individuals. Most of the rooms painted here belong to houses that were created over a period of time; they were the homes of large families and usually the workplaces of several servants. Such a home might be as much the centre of a community as a family house. Many of these interiors are filled with beautiful, well-cared-for objects collected over the centuries.

For some artists, these interiors hold associations completely different from the paintings that convey personal intimacy. Formal interiors present a different kind of challenge to the painter. For example, Fenton House, the subject of Jacqueline Rizvi's watercolours on pages 88 and 89, is owned by an official body, and its rooms are open to the public. It is, in this sense, more a museum than a real home. But, like other painters of formal interiors, she is painting more than an impersonal room in a big house. There is a warmth about her response that conveys a real empathy, a sense of belonging to the long tradition of beautiful things. But there is also a certain sense of ritual about these paintings and others of similar subjects.

For the artist, one important factor in painting stately interiors is space. A room built to be looked after by many people, intended to be a formal social centre as well as a home, is a large place with more extremes of scale, more perspective than the average interior. In some very big rooms, especially those with a lot of daylight, aerial perspective can be as evident as in a landscape – the far side of the room may be considerably less defined than the foreground.

All the artists in this section expressed specific interest in the objects they paint. A room full of beautiful things is frequently a desirable subject, and painting such a subject may make the painting itself into a beautiful object, a desirable and collectable item in its own right simply by virtue of its content. But this is not necessarily the case. Edmund Fairfax-Lucy, accused of "only ever painting beautiful things," and challenged by a friend to paint something ordinary rather than elegant, included a television set in one of his paintings. We see from the result that the television does not make his painting any less "beautiful." The artist's perception of light and colour, the way he paints, creates the "beauty" in his pictures.

Julian Barrow, who could be called a formal painter, is thinking of generations to come when he paints his – usually commissioned – interiors. His aim is exactly that of the person who commissioned the picture – to document a place for posterity. To Julian Barrow, it is all-important that he gets an accurate, almost topographical portrayal of the room and the furniture in it. There may come a time, he feels, when neither will exist – the present occupants may have moved elsewhere; children will have left home; the family collection could be split up and scat-

tered. His paintings are a record.

There is a longer tradition of painting formal rooms than any other types of interior. For centuries patrons have wanted their houses painted, either as the central subject or as an incidental inclusion in a picture. Family portraits were naturally painted with the most elegant room in the house as a suitably impressive backdrop.

In the formal interior, architectural forms and decoration are frequently in evidence. These do not necessarily demand a detailed or literal representation by the artist, but they often have considerable influence on the subject overall.

We have to separate in our minds the difference between a formal subject and a formal painting. Turner's atmospheric paintings of the stately home at Petworth were not formal renderings, even though he was painting an architecturally formal house. They are personal impressions, not grand documents. Similarly, the paintings in this section are not necessarily formal, even though the elegant subjects make them less intimate than many interiors. It is not the paintings themselves that are formal. Jacqueline Rizvi's watercolours are colour sketches, freely painted and not in any way formal. Conversely, many Dutch interiors are formally observed, composed and painted, even though the subject is often extremely homely and humble.

There is a lot of both black and white in my oil paintings. A little black goes a long way, so I don't get through a vast quantity of the actual pigment – but, even so, I rely heavily on lamp black in all my work. I mix white with brilliant colours, not only to lighten them, but also to make them dull and cool. It is the exact opposite of working with watercolour – with pure watercolours, the white is the white support, and colours are lightened by spreading them transparently on the white paper. This increases their brilliance instead of making them duller.

Edmund Fairfax-Lucy

The Library; 5pm by Edmund Fairfax-Lucy. Oil on canvas. 38cm×33cm (15in×13in)

The artist is an admirer of Dutch interiors; he likes the content and the domestic nature of these paintings, and he also likes the dramatic tonal contrast found in many of these works. In this painting, he achieved a sense of depth by using techniques similar to those of many of the Dutch Masters. His approach was to use glazes, with a thin layer of burnt sienna under the darkly glazed shadow areas in the picture and pale yellow ochre under the strongest light tones. To increase the sense of depth, he then used a grey glaze over the background colours. The carpet is vermilion, mixed with white for the half-tones. With oil paints, he explains, white can be mixed with a bright colour in order to make it appear duller.

Edmund Fairfax-Lucy always works on an off-white ground, but he stresses that the colour of the ground must always be totally relevant to the painting. This is especially true if the picture is to be photographed; in that case the ground frequently becomes overemphasized.

Painting for posterity

The Print Room *by Julian Barrow. Oil.* 30cm×41cm (12in×16in)

This interior was commissioned, as a surprise present for the occupant. Working hours were therefore restricted, and the artist took care not to leave any evidence that he had been working in the room. Even the smell of the oil paint would have betrayed his presence.

Light was a major consideration in this painting, as it is with all Julian Barrow's work. He loves contrast and generally prefers interiors that have a strong, directional source of light, such as a window. Highlights and reflections are also important, and he occasionally leaves an area of unpainted white canvas to represent a patch of natural light.

Most of Julian Barrow's work is commissioned, and he is always intrigued by *the objects he paints. It makes his job more interesting and the painting more meaningful, he says, if he knows something about the subject – the history of a piece of furniture, for instance, or who once lived in the house. He also specializes in "conversation pieces," paintings of figures in their own surroundings, usually domestic. He finds this a particularly satisfying genre because it combines two fascinating subject areas – portraits and interiors.*

The Print Room *was painted entirely from life, with no preliminary drawings or photographs used as reference. Julian Barrow used a fine sable brush to draw the subject directly on to the canvas with thin paint. As usual, he worked from a wide selection of colours on a toned ground.*

Venetian Interior by Julian Barrow. Oil. 41cm×30cm (16in×12in)

F
or me, painting interiors is a way of documenting a way of life. Accuracy is terribly important... I like to record an interior in absolute detail – it makes it more interesting for future generations... especially these days, when family collections have been split up, and fads and fashions are changing so quickly. My own fascination with interiors started as a child, when I was looking at some old drawings done by a great aunt and recognized some of the furniture

Julian Barrow

A beautiful palazzo on the Grand Canal in Venice was the setting for this rich interior. The beautiful old building was restored to its former 17th-century glory in the 1920s; its elegant space and traditional colours inspired the artist to paint a series of pictures featuring many of its rooms.

Quality of light was so important here that Julian Barrow usually returned to his painting at the same time each day in order to capture precisely the filtered sunlight and characteristically mellow shadows. Pink damask walls are typically Venetian, and here their rose-coloured glow pervades the whole painting, evoking a warm, slightly mysterious atomosphere.

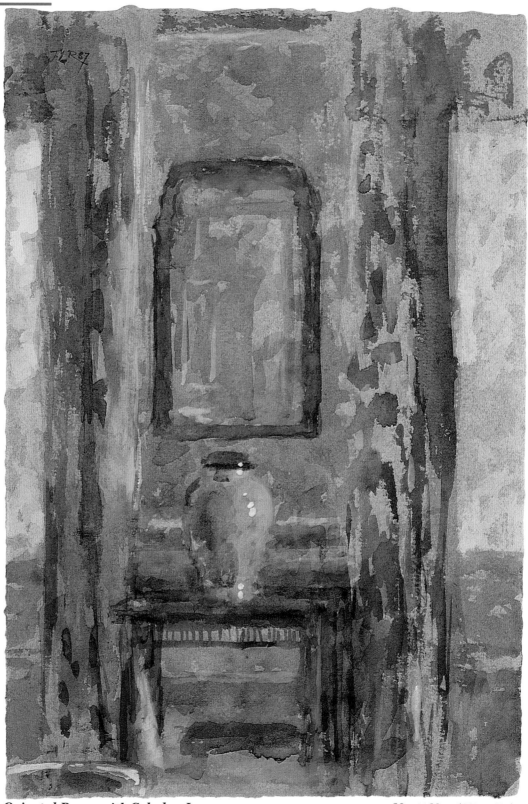

Oriental Room with Celadon Jar *28cm×22cm (11in×8in)*

Dining Room *22cm × 28cm (8in × 11in)*

Blue and White Porcelain Room

Yellow Drawing Room, Worcester Alcove

Interiors at Fenton House *by Jacqueline Rizvi. Watercolour and body colour on paper.*

Jacqueline Rizvi was invited to spend several days painting the rooms of Fenton House, a beautiful old building in north London. She limited herself to an hour per painting because she wanted each one to look fresh and light. As a result of this self-imposed time limit, Jacqueline Rizvi completed many paintings in the course of a few days. Encouraged by the subject, and by the limited time available, she worked very loosely, with more fluidity than usual. Some of the paintings failed and were rejected by the artist, but none suffered from being overworked or from "being something between a sketch and a finished painting."

She loves Fenton House because it combines elegance with a sense of intimacy, and – because it is not too large – it has a strong domestic quality. It is, she says, "like a real home." Each room has a different character, and each is full of objects, all of which are beautiful in their own right.

The Fenton House paintings are the same size, and are all painted on cool grey tinted paper. Jaqueline Rizvi chose not to stretch the paper – partly for reasons of speed and partly because she chose to apply the colour fairly drily rather than use a lot of water with the paint.

Domestic interiors and pretty scenes are not part of Sophie Macpherson's world. She is interested, not in the home, or in household objects, but in the man-made environment, in the industrial and architectural landscapes that play a very major part in most of our everyday working lives.

Planks stacked against the wall of a friend's wood yard appealed to Sophie Macpherson because of their repeated patterns and abstract shapes. She made several drawings and took some photographs before embarking on this large oil painting in her studio. She found the composition easy because "everything was so straight and geometric". It was largely a matter of arranging the shapes.

Neutral colours – mainly black, white and earth tones – were applied thinly on a primed cotton duck canvas.

The Wood Yard by Sophie Macpherson. Oil on canvas. *122cm × 107cm (48in × 42in)*

8
PLACES OF WORK

The artist has followed the worker indoors. Paintings of the peasant toiling in the open fields, the fisherman mending nets in a picturesque harbour, or the ploughman set against receding furrows, have become romantic and nostalgic rather than what they once were – images of the workplace. Such scenes still exist, but for most people they bear little relation to reality, certainly no association with work. They belong to a byegone age. Meanwhile, work itself has increasingly moved into the factory, the office, the design studio. The rural scene continues to hold a fascination for the artist, but it is increasingly the interior rather than the landscape that depicts the place of work – that familiar place where many of us spend about a third of our lives.

The nature of the work dictates the atmosphere of the working interior. The scene may be tranquil and quiet – a place of study, perhaps, surrounded by books; the designed gadgetry of a modern executive's office; or the solitary writer's lonely, paper-strewn desk. It may be spacious, like a factory. For some, the idea of a place of work evokes an image of ranks of moving, busy figures; for others, patterns of work stations, where individuals tap at computer terminals. These may not sound very romantic – but neither would the furrow have looked romantic to the ploughman. The workplace is an environment dictated by the functional needs of the occupation and, as such, it

has appealed to artists for centuries.

The rural themes of such painters as Pieter Breughel and Jean François Millet arose, not out of nostalgic yearnings but because the artists were not that far removed from the work and workers they depicted. Their pictures gave way to new 'work' paintings of machines, and machine-like buildings, with people seen against rigid and monumental shapes, like Stanley Spencer's shipbuilding paintings.

Although the materials and objects that dominate modern workplaces would traditionally not be seen as aesthetic, they nevertheless appeal to many of today's artists. Sophie Macpherson paints the inside of a brewery (page 99) – a huge pumping machine, a metal engine. She is attracted by the vast complexity of the mechanism and the painted metal parts, and these dictate the way she works – often with a ruler, defining shapes and using areas of flat, untextured colour. There are no people in the brewery painting, nothing gives away the scale.

An opposite but equally contemporary approach is that of Brenda Holtam, who drew the stone statues of the British Royal Academy (pages 92 and 93) which formed part of her workplace as an art student. The antique nature of the subject suggested the medium, an old-fashioned dip pen with black and brown inks, and the resulting drawings could easily have been done in the eighteenth century. Yet they are con-

temporary and credible reproductions of the traditional and timeless environment in which the young student found herself working.

Inevitably, places of work in paintings tend to be the artists' own studios. The interior, in this case, often plays an incidental role as a background to figures, still-lifes, self portraits, and so on. Yet the atmosphere of the studio still pervades in these pictures. Artists are more familiar with their studio environment than with any other, and studios often reflect the personality of the artists and the type of work they do. The same studio furniture and objects frequently crop up again and again in an artist's work. The light of a particular room will influence all the paintings done in it. Fred Dubery's *Self Portrait* on page 97 takes the influence of the surrounding workplace to an extreme: the canvas itself is shaped to imitate the shape of the studio he is working in, the corners cut off to coincide with the room's sloping roof.

Whatever the workplace, it is the people in it that inevitably attract the artist. Even if they are not actually in the painting, there is an implied presence, a feeling that someone has just left. People at work have always held a fascination for artists; other people's work is always more mysterious than our own, with its unknown processes, unfamiliar materials and enviable skills.

The artist in his or her studio is of great interest to non-artists, which is why people flock to 'artist in residence' schemes at galleries and museums to see the painter painting and the sculptor sculpting. Museums attract visitors by activities that enable them to see how thatching was done, how the American settlers built their homes, and so on. The potter on page 96, for instance, is a friend of the artist, but it is the activity which evokes the interest. There is an obvious fascination with the wheel, the emerging shapes of the pots, and the stooped posture of the potter herself as she creates her products.

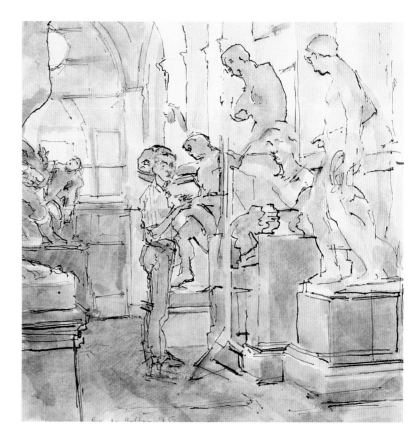

T he dip pen is far more exciting than an ordinary fountain pen. It is also more sensitive, more responsive, and very versatile...you can vary the width of line as you draw by altering the pressure, or you can use the back of the nib to get a fine, spidery line. The marks are alive.

Brenda Holtam

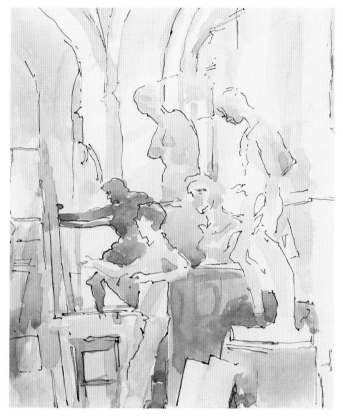 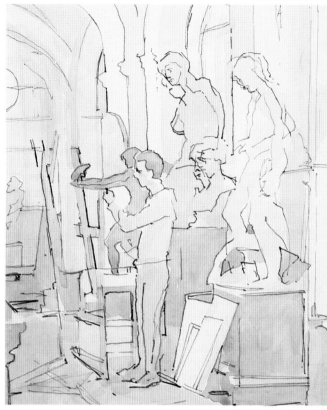

Academy Schools' Corridor *by Brenda Holtam. Dip pen and ink on card.* *35cm × 25cm (14in × 10in)*

Traditional dip pen was the ideal choice for these monochrome studies of the dark stone corridor in the Royal Academy. The varied, undulating lines of this old-fashioned drawing tool combine successfully with the blacks and browns of the ink, producing a subtle, faded look that is well suited to the subject.

Brenda Holtam was intrigued by the way in which the antique statues and the living figures were complementing each other, and she wanted to echo the repeated forms in this series of drawings. However, the scene before her changed constantly as the figures moved around so she had to work quickly. She began with a very minimal line drawing, from which all superfluous line and detail were deliberately excluded. Waterproof Indian ink was used throughout.

When the initial drawing was completely dry, tones were applied with washes of diluted ink. Because the ink used was waterproof, the drawings remained intact and did not run or bleed when the washes were laid over them.

Brenda Holtam applied the various tonal washes systematically, first picking out one fairly dark tone and using it in selected areas throughout the image. When every area of this tone was established, she moved on to other tones, applying each one separately to its appropriate areas. At each stage, every new wash was allowed to dry thoroughly.

A ready-made subject

The quayside studio featured in this interior
is very special to Margaret Thomas because
it represents privacy and peace. It is a "bolt
hole", a place where, in the past, she has
frequently escaped from all problems and
pressures, to be on her own and paint.

This artist does not always have to look
for her subject. Sometimes she notices
something and thinks: "That's a painting!"
When that happens she wants to get on with
it straight away – as was the case with this
interior of her boathouse studio.

As always, she started by making some
drawings and then painted directly from the
subject. The vermilion outline, she says,
provided her with a "key" against which to
gauge other colours and tones. The palette
used here was lemon yellow, vermilion, dark
alizarin, cobalt blue, ultramarine blue,
yellow ochre and raw sienna.

The Boathouse Studio by Margaret Thomas. Oil on board. 46cm×56cm (18in×22in)

In the artist's studio

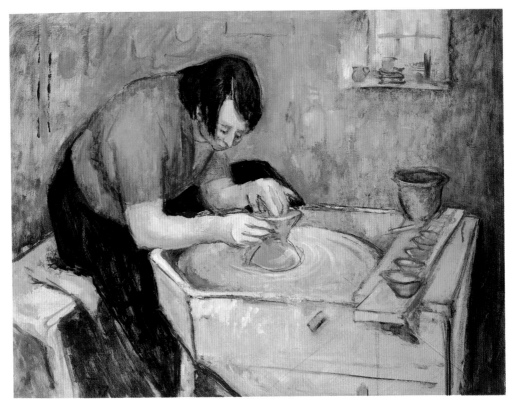

Potter at Work *by Margaret Thomas. Oil on canvas.* *71cm×91cm (28in×36in)*

Margaret Thomas is fascinated by pottery making – by the movement of the wheel and by the shapes it produces. She did this painting from photographs and drawings made during one of many visits to the potter's studio. Although the woman in the picture was a good friend, the artist has always considered this to be a painting of a potter rather than a portrait.

The potter is Katharine Pleydell-Bouverie, a pupil and colleague of Bernard Leach and a much respected artist. She is remembered, among other things, for the beautiful wood glazes that she developed and used.

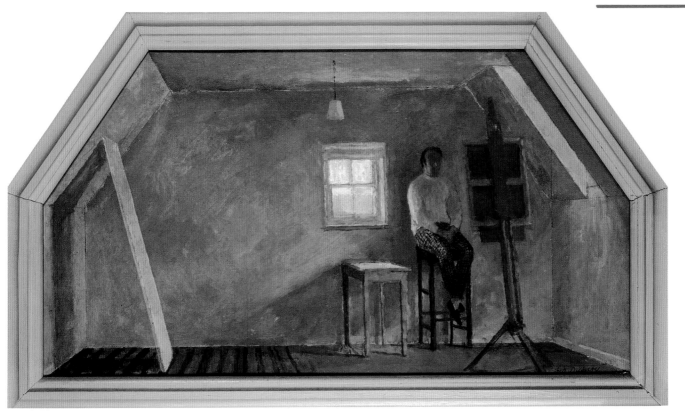

Self Portrait by Fred Dubery. Oil on canvas.

30cm×51cm (12in×20in)

The unusual shape of this canvas was inspired by the artist's interest in Florentine art, especially the way in which paintings were shaped to fit into the surrounding architecture. In a similar spirit, the top corners of this canvas were cut diagonally to accommodate the shape of the studio ceiling in the subject.

The artist worked partly from life, setting up a large mirror at one end of the studio. He also referred to a detailed working drawing. The painting was done on a grey ground, using a selection of warm and cool colours. Paint was generally applied thickly and opaquely, although the artist contrasted this with more transparent colour in certain areas.

Machinery

Before she starts a painting, Sophie Macpherson makes several of these preliminary drawings. These are usually very precise and are all done with paintings in mind, the object being to get down as much solid information as possible. They are not intended as finished works but can be as rough or mechanical as she feels to be necessary. Preliminary drawings, such as the ones above, are always done in pencil, although the artist occasionally uses coloured pencil or crayon to make colour notes.

Usually, the artist uses the drawings to work out complicated constructions and to help her decide on the best composition. Apart from a ruler for straight edges, she does not use any drawing aids or a geometry set.

Industrial Interiors 41cm×30cm (16in×12in)
by Sophie Macpherson. Pencil on paper.

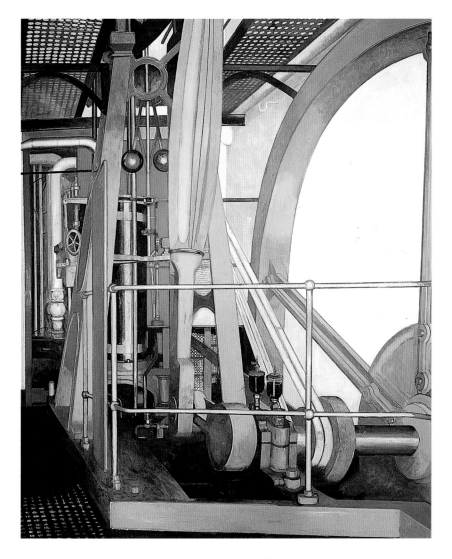

Youngs' Brewery *by Sophie Macpherson. Oil. 142cm×114cm (56in×45in)*

Before she started painting this rather daunting interior, Sophie Macpherson spent many hours in the brewery, making drawings and taking photographs. The red and green metal construction is a "beam" engine, a pump that moves steadily up and down; the artist wanted to become acquainted with its shape and structure before starting to paint it.

Using the drawings for reference, she enlarged the subject onto the large primed canvas. This was done by eye, with the aid of a ruler. She used paint quite thinly, building up the image very gradually in blocks of colour, and redefining the blocked-in areas with thin lines. Despite the large scale of the canvas, the artist chose to use small and medium sized artists' brushes. These gave her more control over the paint strokes than broader brushes. She worked from a wide selection of colours, the main colours for this painting being cadmium red, viridian and black.

Shop interiors

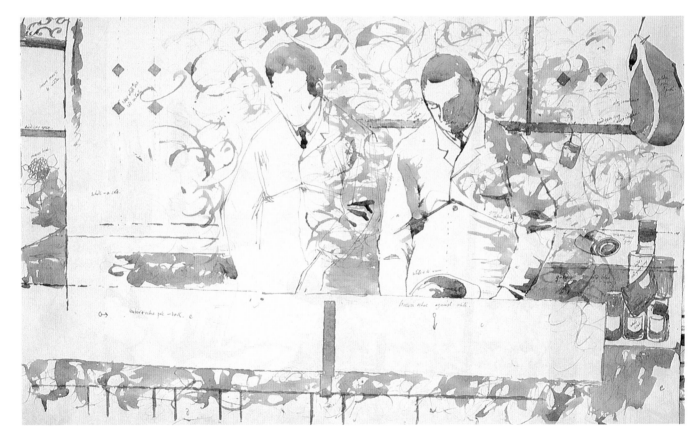

The Butcher's Shop by Lionel Bulmer. Pen and ink on paper. 43cm×30cm (18in×12in)

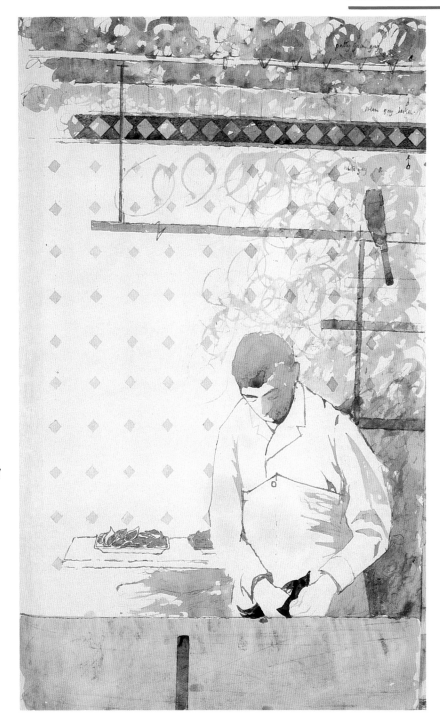

Lionel Bulmer was a student when he made these drawings (above and opposite) of a beautiful old tiled butcher's shop near his home. The butcher, who took a friendly interest in the young man's work, insisted that he stay at the back of the shop, well away from the customers. The pictures are two of a series, all done with Chinese ink and an old fashioned dip pen. Although the artist later made an oil painting from the drawings, they were not intended to be studies but were done for their own sake and because the artist liked the subject.

The nice thing about Chinese ink, he says, is its lovely brown colour. It comes in stick form and has to be ground down in water, traditionally rainwater. Lionel Bulmer kept two jars of ink, a light tone and a darker tone at hand. Tonal washes were applied with a sable brush.

For the line drawing, the artist chose a nib which allowed him to create very thin lines when holding the pen in the normal position and block in solid areas of tone with the broad reverse side of the nib. The lighter ink mixture was used mainly in the initial stages; the darkest ink for the dominant lines and deep tones.

30cm×43cm (12in×18in)

Before she did this painting – one of a series – the artist had been living in an old stone house set in the slate mountains of Wales. Its recessed windows and the dim, shadowy interior had dictated the colours of her paintings there – mainly cool blues and greys, and brilliant greens.

When she came to paint this interior, she found the contrast of the wooden beach hut looking down on a vast expanse of sand both exciting and stimulating. "I was surrounded by flat planes and warm tones and found myself using pinks, ochres, greens and sand colours", she says.

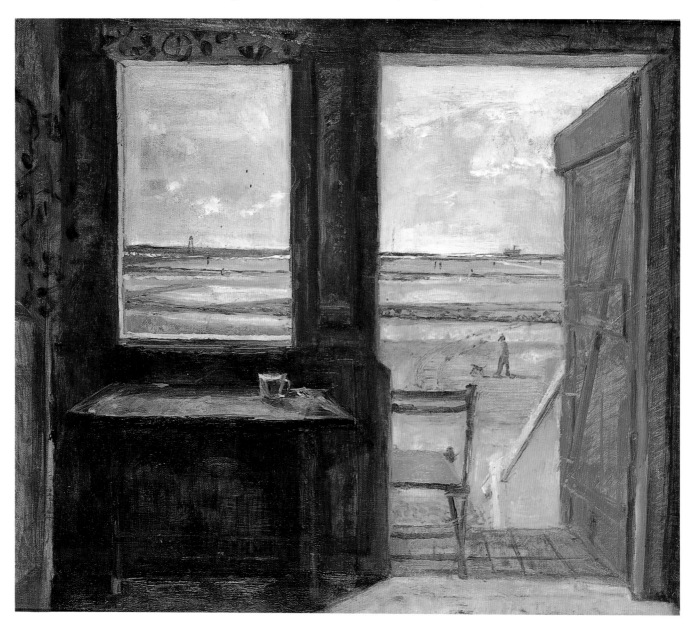

Beach Hut Interior with Table by Emily Gwynne-Jones. Oil on canvas.

30cm×36cm (12in×14in)

9
VERANDAHS AND VISTAS

In this chapter, the interior moves out-doors. The emphasis in the pictures is on the view outside, but it is a view that is perceived and pictured from within. Sometimes it is a view or vista glimpsed through a window or open door; some-times the "room" is a terrace or veran-dah, an extension of a building that is partially indoors and partially out-doors. The paintings are still very much part of the interior genre and are still concerned with people and the space in which they live.

Many artists find pure landscape painting difficult. Vast space and even, all-embracing light can defy the seem-ingly impossible confines of a canvas or a single sheet of paper. But when, within the same picture, a landscape can be contrasted and compared to the iden-tifiable space and light of an interior, the "outdoors" becomes far less daunt-ing. Landscape looked at from within can be like a familiar extension to the living room.

A vista may be broad and spacious, but it is always seen through a particu-lar window or door or from a particular verandah – a view an individual sees every day that is a constant backdrop to his or her life. It is a view that does not physically change; the occupants are as familiar with it as they are with the interior of the room from which they see it. In this sense, parts of the outside world "belong" to people and can tell us something about their lives. *Notice Board on the Quay*, by Margaret Thomas, for

instance, shows a view with which she has become intimately familiar – the view seen from her studio window. She paints it with the same affection and understanding with which she paints the objects inside.

In the verandah and terrace views, the artists are very concerned with look-ing inward, as well as outward. The terrace or verandah itself features more prominently than the view. It is still the living space, the area occupied by hu-mans, that most concerns the artist, yet there is always a strong sense of the outside world being brought indoors. Jane Corsellis painted a shady and enclosed verandah complete with chair and shutters, but it still feels very much like an outdoor space – albeit one with a roof, walls and floor. Another verandah picture, Niel Bally's *Terrace, San Pablo*, looks inward from the outside, offering a glimpse of a covered wooden terrace through the trees. This too is a piece of outdoor space, borrowed and utilized by people.

Both Jane Corsellis and Niel Bally were living and working in hot climates and the paintings are concerned with heat as well as light. Strong colours and contrasting light and shade suggest strong sunshine. The very hot sunshine outside emphasizes the coolness of the enclosed areas. We can actually sense the change of temperature when look-ing at the painting. The artists often use contrasting "colour temperatures", making use of cool and warm colours to

Cool and warm colour

express the difference between the hot, bold sun outside and the tranquil coolness of a sheltered area.

Emily Gwynne-Jones works in a colder climate, but she also makes use of the properties of hot and cool colours. She "raises" temperature outside her beach hut with warm, earthy, sunny tones. These warm colours pervade the whole painting, partly because of the colours in the wooden beach hut, yet she still manages to "lower" the temperature inside by using darker, slightly cooler colours. Emily Gwynne-Jones also conveys a sense of time by the way she portrays the strong elongated shadows of the hut that are thrown across the expanse of sand.

Painting a vista that can be seen from an interior allows the artist to make interesting comparisons of scale. For instance, a potted plant on a windowsill can be seen in specific botanical detail, while trees on the distant horizon would by necessity be more generalized and suggested.

In chapter three, Doors and Doorways, we showed how artists portrayed views seen from an interior – but they were very different from the pictures in this chapter. They showed a landscape, or another interior beyond, strictly as a "picture within a picture", framed by the doorway and therefore playing a subordinate role in the overall composition. The pictures in this chapter are involved with a more equal relationship between indoors and outdoors. The boundaries between the two are less distinct.

Sketches; North Wales by Emily Gwynne-Jones. 10cm×13cm (4in×5in)

These three sketchbook drawings were done in the attic, a long dark room with little daylight. They were sketches for paintings that were eventually completed in another part of the house where light was better, though "with constant running up and down to check the subject."

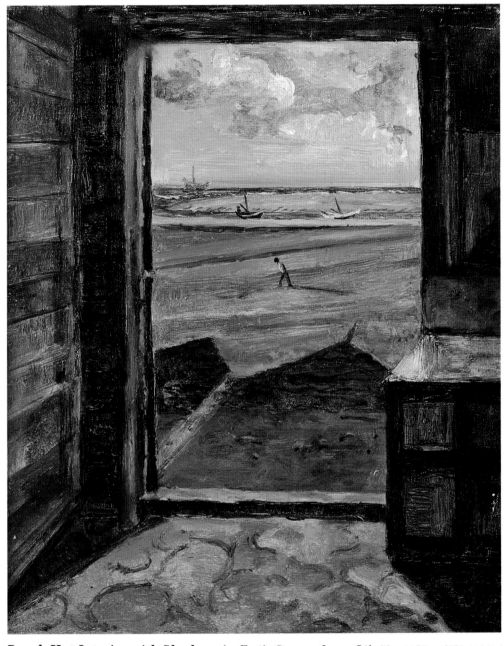

Certain places mean a lot to me, and in all my paintings, it is the essential and special atmosphere that moves me. I have always enjoyed the intensity of views framed by small openings, especially when that view is one of daylight seen from a darker interior.

Emily Gwynne-Jones

Beach Hut Interior with Shadows *by Emily Gwynne-Jones. Oil. 30cm×36cm (12in×14in)*

The small, dark interior of this beach hut made it difficult to paint directly from the subject. The artist could not get far enough back from the work to simplify the subject or work out the colours. This painting was therefore done from drawings although, as she grew more familiar with the subject, she was able to do other paintings of the same subject from life.

It was the contrast between the inside of the shady hut against the warm sand and sunlight, that drew the artist to this subject. The contrast is emphasized by the elongated shadows of the beach hut thrown across the sand. The palette consisted mainly of warm earthy colours – pinks and ochres – with cooler tones of greys and greens.

Customs House from San Giorgio Maggiore
by Alan Halliday. Watercolour on paper.

42cm × 29cm (17in × 11in)

It was the idea of seeing a "picture within a picture" that captured Alan Halliday's imagination when he painted these Italian scenes. They are all exterior views glimpsed from indoors, and he deliberately chose to use the paper horizontally because this left him with lots of space around the frames of the vertical doorways and windows. Thus he was able to include plenty of the interior, the room from which he was painting, in each composition.

Lighting was another important aspect of these watercolours, and the artist was especially interested in capturing the effects of reflected outdoor light on the interiors. Each painting was done at a different time of day, and each contrasts differently with the light of the interior: The Customs House *was painted during the day;* San Georgio Maggiore, *at night; and* Farmhouse in Tuscany, *during the late afternoon. Alan Halliday painted directly from the subject, keeping the image as transparent and simple as possible. Nothing was added to the paintings later.*

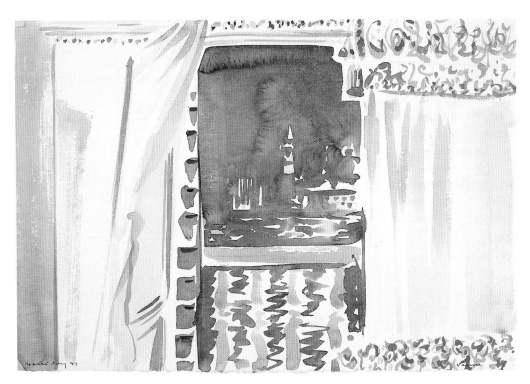

S. Georgio Maggiore from the Danielli Hotel 59cm×42cm (23in×17in)

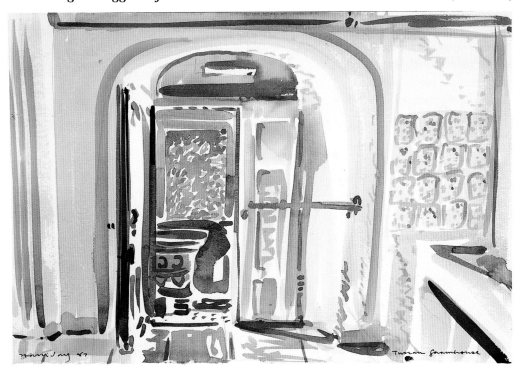

Farmhouse in Tuscany 59cm×42cm (23in×17in)

My approach to watercolour is absolutely purist. The paint should always be used on its own – never adulterated with ink, gouache or any other medium. I use the white paper to intensify the colour; anything else only makes it duller. Occasionally, I paint "wet on wet" – applying one colour over another colour which is not quite dry, or directly onto dampened paper. This is usually done to indicate atmospheric perspective, to give an impression of space and distance. When I paint a subject "close up", I always apply colour on to a dry support, recasting the subject in terms of flat colour shapes. Much of my work has to do with light, and this is always painted on the spot, and only while the light conditions remain exactly the same. I never ever attempt to alter the painting later.

Alan Halliday

Pensione in Florence
by Alan Halliday.
Watercolour on paper.
42cm×29cm (17in×11in)

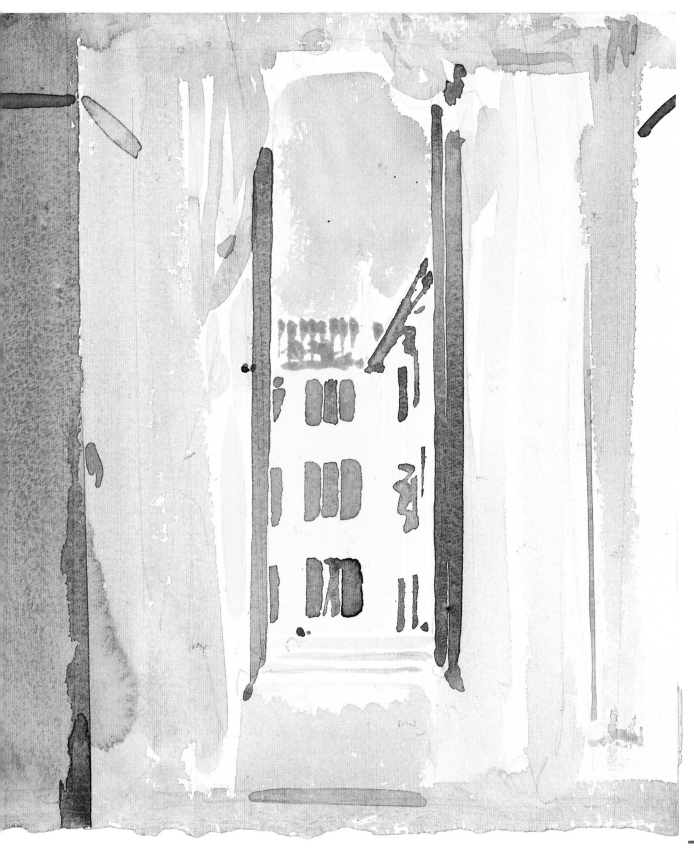

The intensity of light

Tangjong Jara *by Jane Corsellis. Oil on canvas.*　　　　*76cm × 101cm (30in × 40in)*

This verandah was painted in Malaysia, and it was only when she brought the painting home to Europe and saw it next to her other paintings that Jane Corsellis realized just how strong the light had been, and how intense the colours.

For this painting, the artist added one colour – emerald green – to her habitual palette. It was not, she says, a colour she liked on its own, but when used with red it was exactly right for the verandah screen. Occasionally she worked the two colours together on the canvas rather than mixing them first on the palette. This technique allowed the green to show through the reds in places, creating a varied and lively paint surface.

The artist made a number of watercolour studies prior to starting this oil painting, as well as taking photographs of the subject.

These, she says, were of limited help because the camera never really records nuances, and the photos failed to convey the atomosphere of the scene.

Tanjong Jara was completed slowly over a period of about two months. As with many of her paintings, Jane Corsellis frequently put the canvas to one side and turned her attention to something else for a while. This way, she says, she returned "fresh" to the painting and was able to start painting again on a completely dry surface.

She worked from a palette of white, yellow ochre, cadmium red, rose madder (genuine), burnt sienna, burnt umber, ultramarine blue, cobalt blue, cerulean, oxide of chromium and viridian. The ground here was a subdued pink, chosen to complement the greens in the subject.

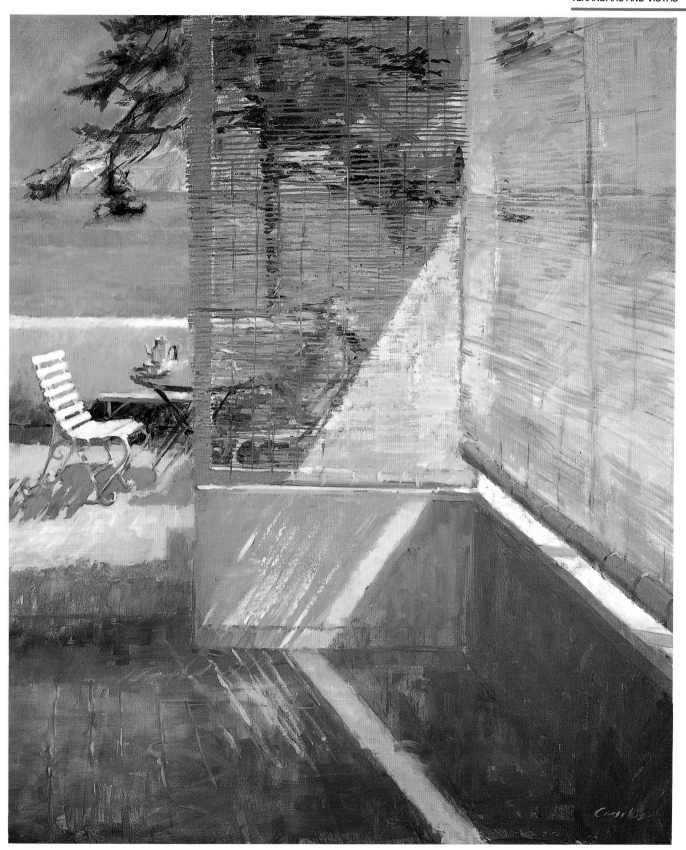

Painting the familiar

I love experimenting with a variety of textures when I am painting. Oil paints are wonderful for this – you can get a combination of thick and thin colour in the same painting. Such versatility and contrast is really only possible if you mix the paint with a medium. I use turpentine and oil of spike mixed in equal proportions. The oil of spike is made from lavender – it's an alternative to turpentine, but smells much nicer. It was a tip given to me by Winifred Nicholson.

Margaret Thomas

Notice Board on the Quay by *Margaret Thomas. Oil on canvas.*

76cm × 64cm (30in × 25in)

Margaret Thomas likes to be familiar with what she is painting. If she knows something well, it is easier to synthesize the image and to capture the essence of that subject. "It is like having an opinion," she says. "First impressions are never quite the same – they are what you have before you develop an opinion."

The notice board is a very familiar sight. People often gather around it, and Margaret Thomas can see it from her studio window. It is a scene that she not only knows, but one she also "understands."

Her initial drawing, painted in red, is strong and emphatic. It survived subsequent painting and provides an important, vibrant quality in the final composition. It also links the more subdued, general tones. Although the artist sometimes deliberately obliterates initial outlines, she felt that in this case they made a positive contribution to the picture.

Window on the Quay by Margaret Thomas. Oil on canvas covered board. 41cm×51cm (16in×20in)

The old quayside building featured in this painting was once a lookout tower, used to spot smugglers and other illicit visitors. Today, its role is less dramatic – the window looks out on a peaceful quayside scene, and the area is occupied mainly by tourists and a few local residents. As the distant, silhouetted crane suggests, the quay is now the site of other, legal and official marine activities.

The subject is dominated by greys and subdued cool tones, and this is reflected in the artist's palette. However, Margaret Thomas used vermilion in small quantities throughout the composition, choosing one hot colour to offset the cool neutrals used elsewhere. The vermilion is brought out by the red geraniums on the window shelf.

A reddish ground, which is allowed to show through in places, also emphasizes the red elements in the picture and helps balance the warm and cool colour content of the painting.

The artist describes herself as an instinctive painter. She tried not to "overconsider" as she worked on this composition – a habit she is happy to cultivate. "I do much better when I paint without thinking," she explains.

Terrace, San Pablo Elta, Mexico *by Niel Bally. Oil on canvas.*

The long, narrow support makes this painting look like a frieze or scroll; You can "read" it from side to side. This effect, which was deliberate, is enhanced by the open composition that allows the viewer to scan from left to right or right to left with equal ease. There are no visual impediments in the picture to halt the eye as it moves across the image. A foreground tree divides the composition into two focal areas, two "pictures within a picture" without spoiling the horizontal flow of the painting.

The brushstrokes are deliberately gestural and rhythmic, allowing the eye to move easily through and around the trees and other elements in the painting.

Colour was also very much on the artist's mind when he approached this subject. His use of complementaries, especially red with green, was suggested by the cool tones of the garden set against the warm colours of the house. This, along with his choice of clear, bright colour, helps express the strong light and heat of the subject.

To achieve such a high colour key, the artist worked from an extensive palette of cerulean, ultramarine blue, Prussian blue, emerald green, phthalo green, sap green, permanent rose, magenta, alizarin crimson, lemon yellow, Indian yellow, cadmium yellow, burnt sienna, burnt umber and ivory black. He painted on a yellow ochre acrylic ground.

Though not strictly an interior, the painting has a place in this book because it is about living space, an area where people walk, sit, eat and talk. Although it is painted from outside, the scene depicted is essentially an indoor one — a series of views of the brightly lit, enclosed terrace, glimpsed through the trees.

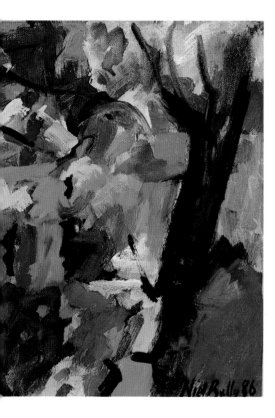

23cm×61cm (9in×24in)

I was living in Mexico when I painted this terrace – a place where I walked daily. The picture reflects my appreciation and pleasure in the scene. It was painted in the morning, with the sun rising directly behind the subject.

Niel Bally

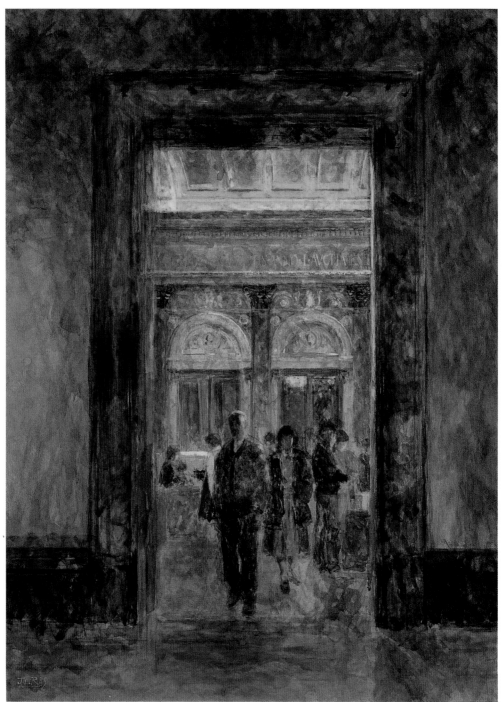

The National Gallery by Jacqueline Rizvi. Watercolour and body colour. 61cm×51cm (24in×20in)

The formal, rather austere interior of this art gallery prompted Jacqueline Rizvi to choose an equally austere composition for her painting. She stood directly in front of the doorway when she made the sketches for the picture, aligning the view through the door with the centre of the painting. Even the main figures, the couple in the foreground, are positioned in such a way so as not to offset the general symmetry of the picture.

10
PUBLIC PLACES

The word "interior" usually conjures up the image of an intimate room, a room that definitely belongs to someone, a place in which a group or an individual have exerted their taste and personality. The position and role of a figure in a domestic interior are crucial to the the painting. Imagine a painting of an empty kitchen. The introduction of a human figure into this composition would alter it drastically, not only taking up a fair amount of space, but also becoming the focal point of interest.

Some of the paintings in this section, however, deal with interiors that are in a completely different realm; they are less intimate, less personal, where the presence or absence of people is no longer such a crucial factor. Imagine, for instance, that more figures were introduced into the nearly empty church in the painting on page 125. Even if the church were filled, instead of containing only a single figure, the spirit and feeling of the painting would not necessarily be very different. Thus, the figures in a painting of a public place are often less important than one would imagine, and the place itself becomes more important for the artist, even though it was designed and built to be used by a large number of people.

Public places vary greatly, however – they include galleries, theatres, cine-mas, churches, cafés and bars. Some of these may be beautiful in themselves, ornate and architecturally interesting. Edmund Fairfax-Lucy's church is un-doubtedly a beautiful interior. Others are not but are chosen as subjects for another reason. Even though the figure may not dominate a painting of a public place in a way it would a domestic interior, the activities of people inside a public place might still be the basic reason for the picture. There may also be interesting objects and shapes within a bare or bleak context. Or perhaps it is the very bareness or simplicity of a public interior that actually appeals to the artist.

One frequent difference between figures in public and figures in a private place is that public people do not necessarily relate to each other. Paintings of a crowd attending a meeting, or of a theatre audience have an obvious focal point – the eyes of the crowd, and the eyes of the viewer therefore, are drawn toward the stage or the speaker. But many public places – art galleries, banks, post offices – were designed for people who are concentrating on something other than each other. A whole hallway can be peopled with individuals and couples who are unaware of each other's existence. Because they are ignoring each other, the composition is

often deprived of what would otherwise be a natural focal point – that of people talking to and looking at each other. Individuals may be looking past each other, or facing out of the picture. They can cancel each other out and even cause discord in a composition, leaving the viewer with no particular figure or group to identify with.

The paintings in this section, however, also include a more intimate type of public place, such as a café. In Diana Armfield's café scenes, the people do relate to each other, even though they may be sitting around in separate groups. This is particularly so in *Tea at Fortnums* (page 121), in which a chef and waitress are facing each other and form a focal point in the middle of the picture. There is a sense of intimacy in this painting partly because of the size of the room; and partly because the figures are larger in relation to their surroundings; and partly because the artist herself was primarily interested in the people. The café recedes into the role of a setting for human activity. However, in the church scene by the same artist, the place again dominates.

The light in public spaces also has to be carefully considered. Large rooms usually have several light sources and they tend to be more evenly spaced and therefore less varied and intrinsically less interesting. To give an indication of space in the room, large expanses of bare wall may have to be included. Jacqueline Rizvi tackles this by using broken colour to enliven these potentially troublesome areas.

One problem peculiar to drawing and painting in public places, is how obtrusive the artist can be, or wants to be. People behave differently if they know they are being observed. Some may object; others maybe curious and want to have a look. Unlike a camera, an easel or sketchpad cannot be whipped out for a moment and then put away. By drawing and painting, the artist is placing a barrier between himself or herself and the subject.

***Icons at the Royal Academy** by Jacqueline Rizvi. Watercolour and body colour on tinted paper.*

41cm×33cm (16in×13in)

The exhibition of icons was held in semi-darkness; the only light was thrown from the illuminated display cases. Jacqueline Rizvi liked the sense of mystery this created, and she was also fascinated by the way the figures appeared to emerge from the gloom. By painting them this way, she created a statement about the icons rather than the people looking at them.

This was not an easy subject to paint. The artist had to work from drawings done in the dimness of the exhibition hall; she also found it difficult to draw people as they constantly moved around. Several pencil studies, including a detailed sketch of the complicated floor tile pattern was made prior to the painting.

Icons was painted on greyish lilac paper from a palette of about 15 watercolours plus white gouache for opacity.

Private View at the Royal Academy by Jacqueline Rizvi. 43cm × 56cm (17in × 22in)
Watercolour and body colour on tinted paper.

These people have never met in real life. They meet for the first time in my painting. I introduced them. It's a fascinating idea. I like sketching people when they don't know they are being observed. Art galleries, restaurants and theatres are all good places for this, and some of the people you see there are very extraordinary. Sometimes I go back with my sketches and put all the figures into a painting. That's when they meet....

Jacqueline Rizvi

Every figure in this painting (above) is a real person, sketched by Jacqueline Rizvi while they chatted, drank and looked at the work on display at this private view. She made lots of quick drawings of individuals and later arranged them in this composition. The painting, done on beige tinted paper, is watercolour, mixed with white gouache in some areas to give the colour varying degrees of opacity.

To paint this scene without having the subject in front of her, the artist needed a record of the art gallery, showing the scale of the figures in relation to their surroundings, as well as its layout and the position of the main exhibits. This sketchbook drawing (left) was large enough to provide her with that information. Anything larger, she feels, would have been far too cumbersome, too obtrusive on such an occasion.

Cafés and restaurants

These drawings were done in the sketchbook which the artist, who is an enthusiastic traveller, carries with her everywhere. To Diana Armfield, sketching is habitual, an ongoing activity that is central to her work as an artist. She is a keen observer and recorder of people, and among her favourite subjects are restaurants and cafés.

A sketch is almost always done with a finished work in mind, and

Café Interiors by Diana Armfield. Pencil and sketchbook.

Diana Armfield inevitably refers to her sketchbook material at a later date, either for a painting or for a detailed pastel drawing. Even though most of these sketches are done quickly, they are all clear and definite. Working from fuzzy, imprecise drawings, she says, is impossible — "I need to be able to see exactly what is happening. The information must be there."

She works with a soft, well-sharpened pencil — usually a 3B, but occasionally a 4B or a 5B. Frequent sharpening, she says, is important. The softer the pencil, the more often it needs to be sharpened to help her get crisp linear detail and dark tonal shading in her drawings.

I never get bored with sitting in cafés, and have frequented the same ones for years. One cup of tea can last me a whole afternoon. I love the activity and sketch anything that takes my fancy. This might be a marvellous group of people, a waiter clearing tables, or even a dog — whatever it is, it is likely to appear in one of my paintings.

Diana Armfield

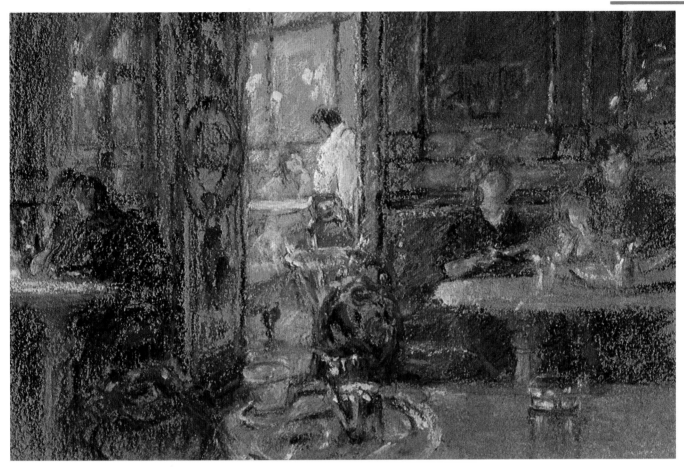

Afternoon at Florian's by Diana Armfield. Pastel. 19cm × 27cm (7½in × 10½in)

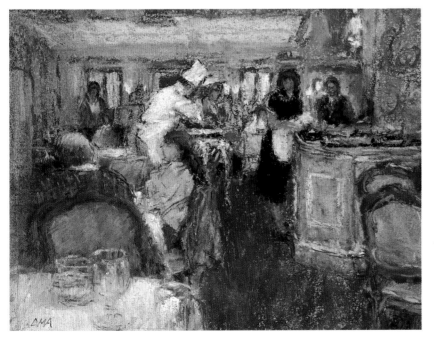

Tea at Fortnum's by Diana Armfield. Pastel. 25cm × 29cm (10in × 12in)

Both these café scenes were done in the artist's studio from sketches and colour notes. She finds it difficult to draw on the spot when using pastels because they are messy to work with. Another problem is the wide range of colours needed for any one picture. Because pastels do not mix in the same way as paints, each colour is available in several tints. Diana Armfield finds she uses about 12 tints of any one colour, ranging from dark to very light — far too many to be easily portable.

Although pastels can be mixed to some extent by overlaying various colours, there is a limit to how far this can go before the paper surface becomes clogged and unworkable. When this happens, Diana Armfield uses a dry, stiff paintbrush to brush out the overworked area.

Interior; San Marco *by Diana Armfield.*
Conté pencil on paper.

33cm×27cm
(13in×10½in)

Diana Armfield has often returned to the church of San Marco in Venice where, attracted to its romantic and mysterious atmosphere, she has made it the subject of many of her drawings and paintings. She does, however, find the dimness of the interior a drawback; the darkness rules out painting on the spot and makes even pencil drawings difficult.

Black and white Conté pencil on toned paper was a good choice because the image was strong enough to be seen even in the dim lighting. Diana Armfield used the three available tones as a sort of shorthand: everything lighter than the paper was drawn in white; anything darker, in black.

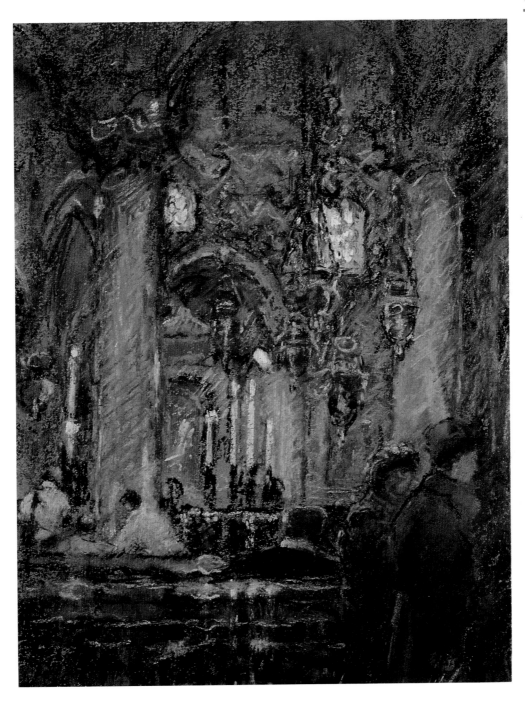

Interior; San Marco _by Diana Armfield. Pastel on paper._ _25cm×20cm (10in×8in)_

This coloured pastel interior was done from the tonal drawing opposite. The colours are rich and jewel-like and the image is strong and well defined. Pastel, says Diana Armfield, is not a tentative medium; the strokes must be emphatic.

She used the side of the stick to suggest broad areas of colour but she never allows this to stand as a final effect because it looks "weak and mechanical". Nor does she usually fix her finished drawings, because of the darkening effect of the fixative. She finds that if she leaves the work exposed to the air for a few weeks prior to framing, the moisture in the atmosphere fixes the pastel naturally.

This lovely coastal church in Brittany is maintained by the local people, and its colours are exactly the same as those they use to paint their fishing boats. Edmund Fairfax-Lucy discovered the church while staying with a friend one summer; it is one of many beautiful granite-built Breton churches that date from the late 16th and early 17th centuries. Typically, the church of Comanna is colourfully decorated, with a carved alterpiece and blue painted ceiling. There is a striking baldachin, a cover over the font, and this, says the artist, is what the painting is about.

Colours in the picture are intentionally cool and austere, reflecting the atmosphere created by the cold, constant light of the north-facing aisle. The painting was done mainly in black, light red and white, with added local colour for ornamentation.

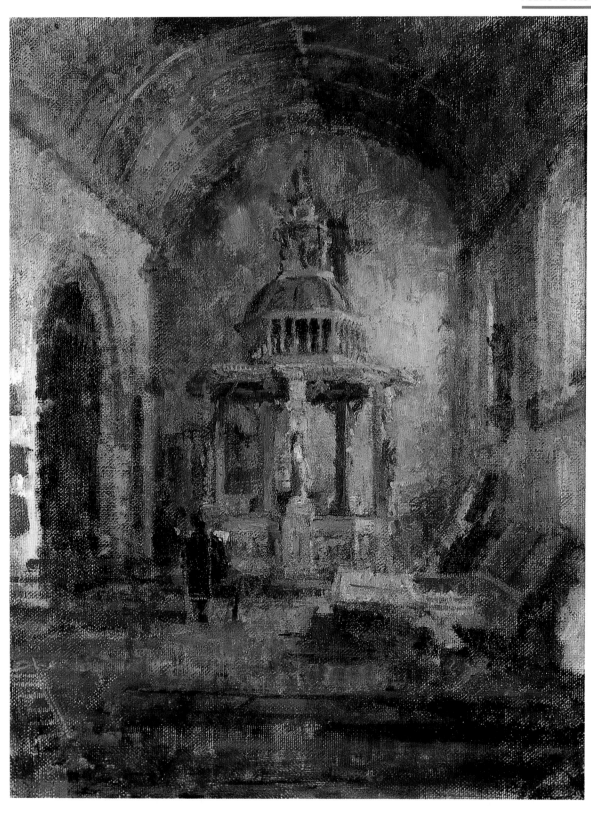

Font in Comanna Church by Edmund Fairfax-Lucy. Oil on canvas. 36cm×28cm (14in×11in)

The architect's dream

All the tiny watercolours in this sketchbook were made when Lutyens an architect and the son of a painter, was in his mid-twenties. Some of the views in the book are imaginary; others, like the three shown here, are based on actual places. The sketchbook, the basis of a fantastic dream palace that Lutyens evisaged building on a Venetian delta, was done for a friend.

Lutyens's earlier designs consisted mainly of country houses; they are picturesque in design, and show evidence of a feeling for traditional materials. Later, his work became more formal. These delicate, rather whimsical sketches incorporate a mixture of architectural styles, including forms of Byzantine and Renaissance origin. Many of the ideas in these early sketchbooks reappeared years later in Liverpool Cathedral and the Viceroy's Palace in Delhi – both designed by Lutyens.

Castles in the Air *by Sir Edwin Landseer Lutyens (1869-1944). Watercolour in sketchbook.* *61cm×51cm (24in×20in)*

When Ken Howard saw these daffodils on the studio window sill, with the light shining behind them and the shadowy view of the village forming the background, he thought he had never before seen anything that expressed light so clearly. This is, he feels, a subject that he will paint for several springs to come. The artist, who had always been interested in light, had never tried a flower painting. He had worked contre jour before, with the daylight behind the subject, but usually outdoors To his normal palette of white, raw umber, yellow ochre, raw sienna, blue black and Indian red, the artist added lemon yellow. There is no blue in Ken Howard's palette; the blues in the painting are mixed from blue black and white, the greens from a combination of yellow and blue black.

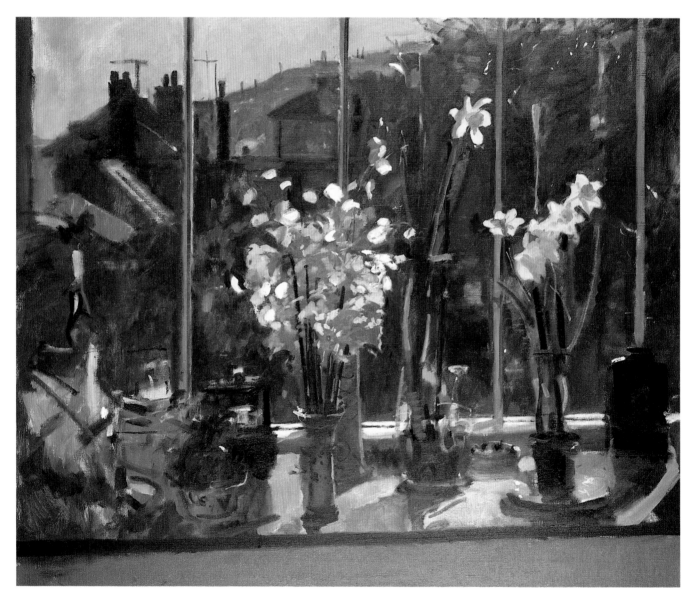

Spring Daffodils by Ken Howard. Oil on canvas.

102cm×130cm (40in×48in)

11
FLOWERS AND PLANTS

Flowers and plants long ago invaded people's homes. Flowers not only arrived in the form of bunches of freshly-picked blooms but also infiltrated the designs used by people to brighten up the appearance of their rooms and domestic utensils. Pots, crockery, knives, clothes, drapes, plaster, woodwork and a host of other household items sport flower and plant motifs. They have been a favourite element of decoration for centuries and there is no sign that we will ever tire of them. Plants have also invaded the home in a preserved state, in the form of bunches of dried grasses and flowers, and the manufacture of artificial flowers is becoming increasingly sophisticated. An artist setting out to paint an interior, therefore, is likely to encounter plants and flowers everywhere.

Although flowers have appeared in design and in paintings for centuries, the realistic representation of the various species was long associated with science. Flower painters, working with oils and watercolours, were essential in the service of botany; their skills were used to make strictly accurate renderings. These pictures were functional and were painted without any attempt at background. But flowers increasingly became a subject for still-life painters, and organic plant shapes started to show up against other objects such as vases, jugs and tabletops.

Flowers are sometimes depicted real-istically; at other times their colours and forms are merely suggested. The juxtaposition of their organic shapes against a background of manufactured structures and household objects is often an attraction for artists seeking interesting compositions. But one of the most fascinating characteristics of flowers is the way they interact with light. They reflect light just as other objects do, but with an added subtlety because of their twisted, complex shapes. And depending on where they are placed, they can also admit light through their thin transparent petals, so that their colours glow with intensity.

When newly-cut flowers appear in a room they bring with them a freshness that many painters strive to capture. The room is a permanent place. It often has a slightly worn look, a lived-in feeling. To depict the temporary freshness of flowers against this background, many artists like to paint blooms in a quick, spontaneous way. Some of the artists in this chapter feel that it is important to work rapidly, directly from life, before the flowers have time to fade. Deftness with the brush is essential for this spontaneous way of working. Generations of Chinese and Japanese artists have mastered this skill and painted beautiful pictures of plants and flowers with smooth, quick brush-strokes that capture the freshness and life of their subjects. The blooms appear so lively that they almost move on the

Flowers in the studio

silk screens where they were painted, often centuries ago. In both Japan and China, writing was done with a brush; so children learned how to make smooth, confident brushstrokes from a comparitively early age.

Some artists use flowers in a deliberate way in order to introduce a particular colour or colours into a composition. They simply go into the garden or marketplace and select the blooms and colours they want. Others prefer to paint what is already there – to come across an interior setting and paint it as it is.

Although there is a particular fascination about the way a vase of flowers can introduce a transient freshness into a room, many painters prefer to work in a meticulous way over a longer period of time, and they often look to the indoor garden to provide a subject. The greenhouse, conservatory or professional nursery cares permanently for its plants and so they are always fresh, even though the contrast with their environment is likely to be less pronounced – they are usually well lit and surrounded by other plants; it is almost an outdoor setting. The plant conservatory or greenhouse has proved a popular subject for interior paintings, providing a variety of organic shapes set against a background of artificial structures.

When they appear in designs, plants and flowers twist and bend over the surfaces of the objects they decorate. The stems of flowers, for instance, might be distorted by the haphazard form of a piece of rumpled clothing, or by the ripple of curtains at an open window. It is as if the two-dimensional surface of the plant motif has been given three-dimensional form. This presents the same challenges to the artist as do the patterns that will be discussed more fully in the next chapter.

The haphazard arrangement of a pile of objects in a corner of her studio gave Margaret Thomas the idea for this painting. She likes the subject to suggest itself to her; she prefers to come across a pile of objects that happen to be there rather than arrange them especially for the painting. She feels happy when painting familiar things with which she feels an empathy, and this corner, with a stack of canvases in the background and a self-portrait on top of them, seemed ideal. The enamel jug is a particular favourite, which she has painted a number of times. The dried flowers and grasses happened to be in the jug – she dislikes formal flower arrangements – and provided a spiky quality that has a marked effect in the final picture. Leaning against the jug is a Matisse postcard – a favourite of the artist. The postcard too, just happened to be there.

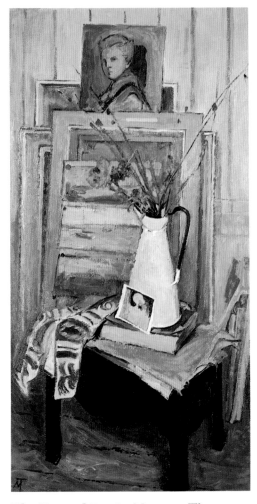

The Enamel Jug *by Margaret Thomas.*
Oil on canvas. *137cm×76cm (54in×30in)*

Every subject has a scale. Every potential painting suggests a certain size canvas. I always know instinctively what this scale should be – it doesn't depend on the subject's actual size. I don't think about scale very much. I don't make a conscious decision. But with flowers, I find that I almost always paint the subject more or less life size.

Margaret Thomas

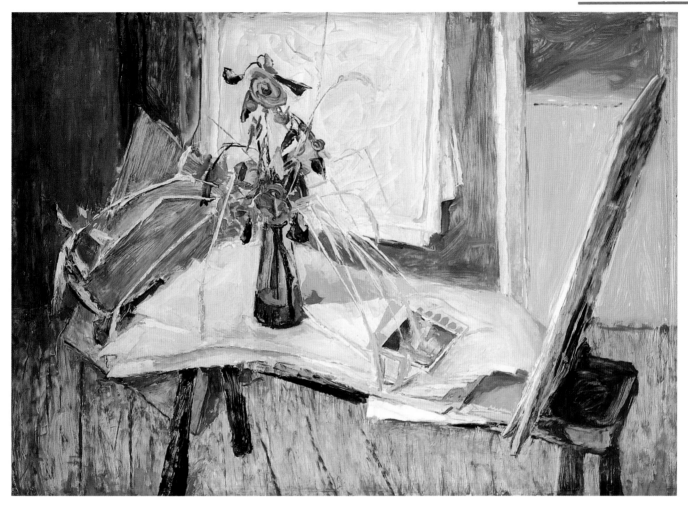

Dead Flowers on Donkey by Margaret Thomas. Oil on vinyl. 76cm×107cm (30in×42in)

The flowers on the "donkey"
– a form of easel that
allows the artist to sit –
have been painted on a
surface which Margaret
Thomas found so attractive
it was rather dangerous –
"almost too easy." Its
semi-opaque surface makes
the colour look intrinsically
attractive. The unusual
support, a sheet of thick,
translucent vinyl on a
wooden stretcher, became for
a while a great favourite of
the artist, who found its
matt surface "very receptive
to colour, almost like
painting on tracing paper."

Oil on canvas. 102cm×66cm (40in×26in)

Studio Cyclamen (left)
by Margaret Thomas.
Every year for 25 years, a
friend gave Margaret
Thomas a cyclamen as a
present. She is so fond of
these flowers that she says
she is addicted to them.
However, they were not
positioned in a special place
for this painting; it just
happened to have been set
down on a yellow cloth.
When the artist saw the
cyclamen against stacked
canvases and wooden
cabinets, she decided to do a
painting. Typically, she felt
she had "caught" the
arrangement "unawares."

131

Watercolour on white

For several years, Alan Halliday has returned to a friend's studio in Paris – a studio he describes as an Aladdin's cave, full of antiques and old fabrics. There is always something to paint, always an "instant" still-life, he says. For this painting, he added a bunch of tulips to the other objects in the studio.

Although this painting is extremely bright and vibrant, the artist used only seven colours, working from his usual palette of Winsor blue, yellow ochre, cadmium yellow, crimson vermilion, burnt umber, cobalt blue and ultramarine blue.

Alan Halliday deliberately incorporates a lot of white space into his compositions. The pure white of the paper, he says, makes the colours "sparkle". He never uses white paint, preferring to incorporate the whiteness of the paper into his paintings. White paint, he maintains, is for oil painters.

Still-life in Montmartre by Alan Halliday. *Watercolour on paper.*

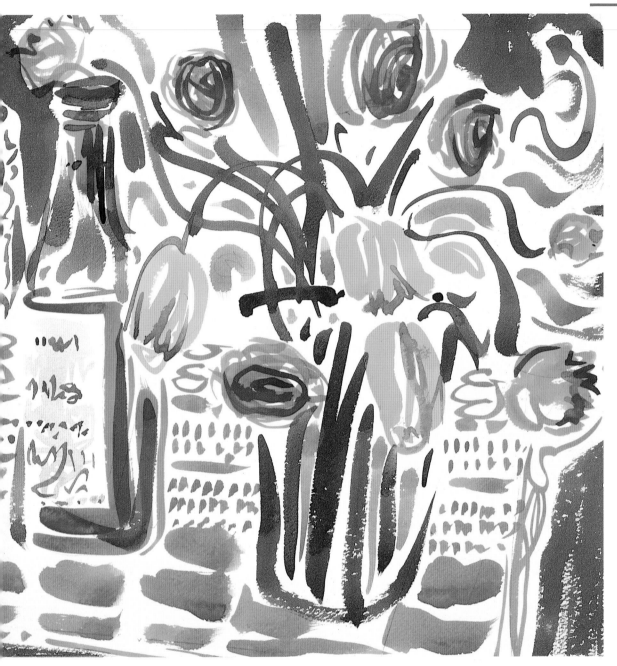

42cm×59cm (17in×23in)

Chelsea Flower Show by Jacqueline Rizvi.
Watercolour and body colour.

27cm×34cm (10in×13in)

The annual Chelsea Flower Show, one of London's major attractions, is always crowded, and this presented a problem to Jacqueline Rizvi when she decided to do this painting. The picture she wanted to paint was of the old-fashioned roses display – she liked the whites, lilacs and pinks of the blooms – but she was unable to do any painting inside the packed and bustling marquees, where gardening enthusiasts swarm round the colourful displays. She took a sketchbook to the show and made drawings and notes, using her experience to remember many of the colours and tones.

She has trained her memory to recall visual detail and colour. Yet, when working at home later, she encountered a typical problem: "You always find you are working with too little information, no matter how detailed the sketches may be. You have to add to your records, not by making things up, but by using logic. You know what must be there."

Jacqueline Rizvi worked on a neutral-coloured paper, using a combination of watercolour and white gouache. The gouache turns the watercolour into an opaque paint but allows control over opacity.

Chiswick House Conservatory by Fred Dubery. Encaustic on canvas. 64cm×81cm (25in×32in)

A mixture of oil paint and wax – encaustic
– was used here to achieve a transparent
effect. The artist had just completed a
commission using tempera and wanted to
capture the same sense of transparency with
oils. He decided to use encaustic to paint the
conservatory, "a beautiful structure, a
marvellous place, and full of camelias at
the time". Turpentine and beeswax were
melted into a jelly-like substance. "I mixed
this with the colour and it made the paint
work like transparent polish." In some
ways the artist found it like working with
watercolour because of the white ground.

This is watercolour used in its purest sense: no opaque gouache has been used, nor have the watercolours been mixed with any other material. The artist did not even use a pencil for an initial drawing but painted directly on the paper. He suggested the position of the flowers and pattern on the kimono with a very watery line of paint. "Flowers are so short-lived that you have to get them down while they are there and fresh."

David Remfry diluted his paints with a great deal of water for this painting. The artist likes to paint loosely, allowing the colour to create its own effects. He started at the top of the picture, working from the top to the bottom because of the watery consistency of his paints. The classic technique of using white paper to create light effects is particularly important to this artist. "To me it actually looks like real light shining through the colour."

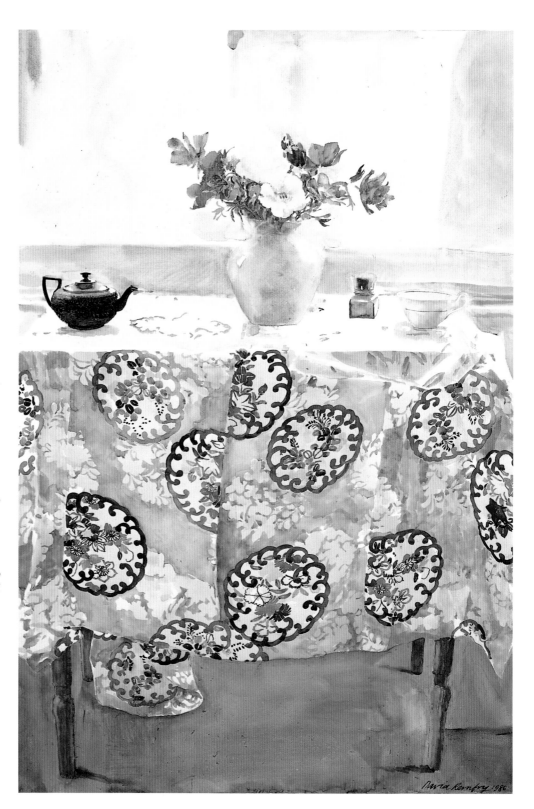

Still-Life; Kimono Tablecloth by David Remfry.
Watercolour on paper.

91cm×69cm (36in×27in)

12

PATTERN

The world of the domestic interior is dominated by pattern, and this poses problems that artists tackle in different ways. As soon as the artist seeks to paint interiors, patterns – the deliberate products of other human minds – will be encountered everywhere, on curtains, carpets, furniture, clothing, vases and ordinary kitchen crockery.

Usually, the patterns follow rules; they have a symmetry and rhythm or they repeat themselves. But these orderly designs are frequently interrupted and distorted by the everyday life going on in the interior. The designs, which were conceived and born flat, become bent, distorted, partly hidden by the people who live with them. Patterned fabrics are often found draped over other objects; a piece of clothing may be flung across a chair. Furniture, which may have its own pattern and be accompanied by the effects of light and shade, will interrupt the order of a carpet.

It is for the artist to decide how prominent these patterns will appear in the picture. Interrelated designs might become the main feature of a work that tends toward the abstract or flat, or they may fade into a more subdued or impressionistic background.

Patterns can also be used to describe form. One artist here, for instance, paints in flat shapes of colour without acknowledging the form of the subject in terms of light and shadow. The distortions of, say, a pattern of stripes as it follows the contours of a sofa are sufficient to describe the form, the structure of that piece of furniture.

A flat, surface pattern will change tone within a subject, depending on its position in the picture and how the light falls on the patterned surface. The artist must then cope with the shifting tones, with light and shade across what may be a very complicated pattern. Some painters will aim for an approximate representation, capturing the overall effect rather than making a mechanical copy. Sometimes an artist develops a personal formula or technique for representing a particular design. One artist whose work is illustrated here has done a series of paintings featuring the delicate pattern-work of lace, and has become skilled at depicting lace patterns with brushstrokes of light paint on dark backgrounds, such as a white tablecloth on a wooden table. The lace has tempted the artist into a whole new avenue of exploration and experimentation with black and white pattern.

Conflict between the idea of surface pattern, on the one hand, and painterly values, on the other, never really goes away. Pattern, with its symmetry and hard-edged clarity, can be in complete contradiction to the hazy, indistinct light of many interiors and to the amorphous, rounded or organic forms present in the subject.

The artist must accommodate these conflicting aspects. The French "Intimist" painter, Edouard Vuillard, who is noted mainly for his representations of interiors with figures, interpreted pattern in purely painterly terms. His patterns, approximated as strokes of paint, change tone within a motif; from dot to dot or from stripe to stripe. But the tones always work within the image rather

than exactly copy the subject's surface.

Although many painters aim for an overall impression, representing designs with painterly brushmarks that indicate the general feel of a pattern, others take the opposite approach. There have been painters who see pattern in everything, even mundane objects. They represent the world as pattern, as interrelated shapes. Henri Matisse, who in the early 20th century had become influenced by Algerian and Near Eastern art and decoration, took subjects from real-life settings and "patternized" them by de-emphasizing forms, flattening shapes and colours and using repeated images. Matisse and others thus turned realistic images into flat patterns rather than trying to create the illusion of space and form.

There are many cases of prominent painters becoming fascinated by pattern, and here we reach a point where painting becomes closely linked with the decorative arts. Painters themselves turn to decoration, to painting pattern on actual objects. The artists of London's Omega Workshop, a pre-war arts and crafts movement, took this idea a stage further. They often used their decorated objects as subject matter in their paintings, bringing the objects back onto the canvas.

A sense of history is also sometimes involved. The patterned interior of a church might represent the ideas of someone working centuries ago — someone as committed to design and decoration as today's artist who seeks to recapture their work in an interior painting. These ancient motifs are thus seen in the context of the ideas and artifacts of a modern culture.

But there are more ordinary, everyday factors involved in the patterns found in interior paintings. Patterns indicate the taste of those living in the room interiors and thus help to convey a sense of personality, a glimpse into another person's life and environment. Patterns show how humans have made their impact upon a room.

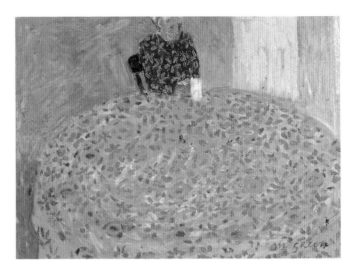

Oil pastel on cardboard. *25cmx30cm (10inx12in)*

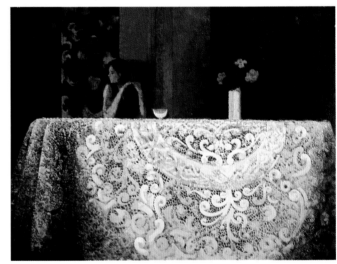

Oil on canvas. *76cmx102cm (30inx40in)*

Green Tablecloth *by Margaret Green (top).* *"When using oil one tends to paint realistically, you can't do this with oil pastels — which is why I like them. I have never admired the ability to get things dead right," says Margaret Green, who used pastels for this drawing of a patterned tablecloth and the seated figure of her mother. She finds she can mix the colours to some extent by overlaying and working into the pastel. Sometimes she blends by rubbing.*

Waiting *by Lionel Bulmer (bottom).* *The idea for this painting came to Lionel Bulmer one Christmas, when he was looking through a lace-curtained window at the snow. "Normally you wouldn't notice white lace, but if it is snowing the light throws out the pattern," he says. The experience started Lionel Bulmer on a whole series of paintings about lace. He became fascinated by the fact that lace encouraged him to paint a "no-colour picture."*

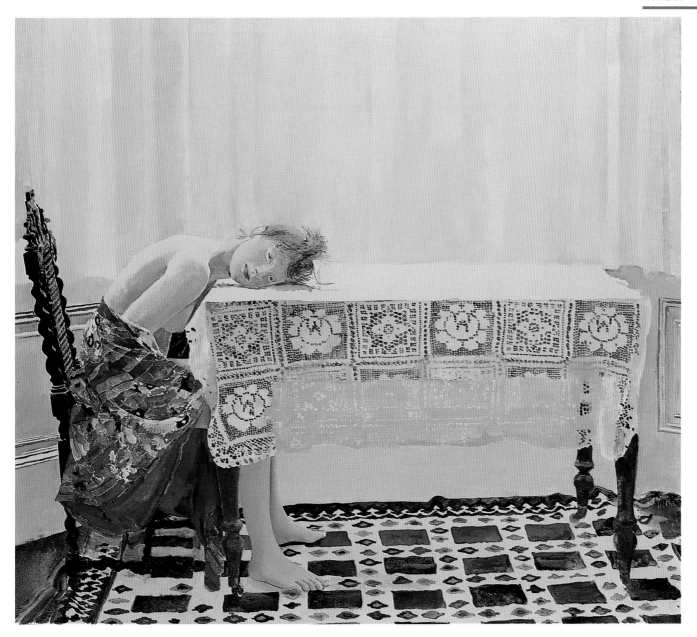

Girl Listening to a Table by David Remfry. Oil on canvas.　　　　91cm×112cm (36in×44in)

The artist has drawn this model, Juliette, many times; usually she posed sitting bolt upright in the chair. When she slumped onto the table to rest, he decided he liked that pose better – it was a more attractive idea.

A central theme of this picture is the variety of patterns. The patterned carpet and fancy lace cloth were not there originally – they are a contrived set-up arranged specially for the picture. The ornately designed carpet – a kilim – was borrowed for the occasion, as was the lace tablecloth. The kimono was one of the artist's own collection; the design is one traditionally worn by young unmarried women.

Despite its compexity and various overall patterns, David Remfry did not draw the subject in pencil onto the canvas before starting to paint but worked with a brush directly on the white support. However, he did refer to a separate, "well worked out" drawing. This, he says, had anticipated and solved the problems of the subject in advance, and it enabled him to avoid possible pitfalls in the painting. His drawings are linear, contain no tone and are very detailed. Like many of his compositions, the layout of this painting is simple and symmetrical: "I like order and balance in my work. The painting should not look confused."

Shapes of pure colour

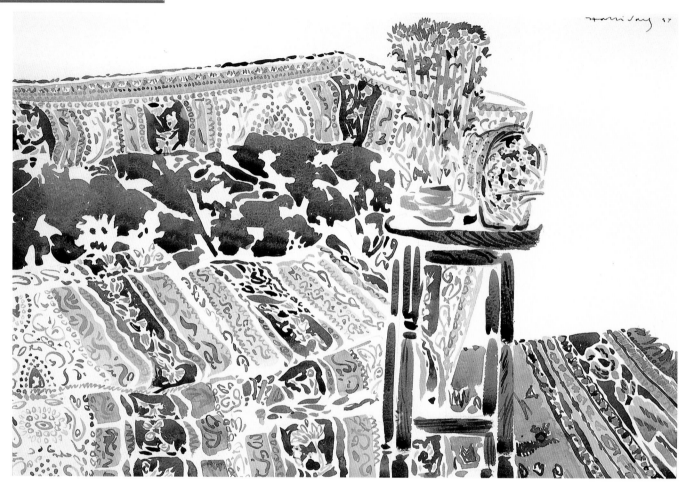

Interior with Mimosa *by Alan Halliday. Watercolour.* *42cm×59cm (17in×23in)*

This artist paints all his subjects in terms of flat shapes of colour, yet a sense of space and form remains in his art, despite his rejection of shading and blended colour. "There are no shadows, no chiarascuro in my work," he says. Space and volume are suggested because the forms are described by the flat shapes themselves. For example, in this painting of a sofa and table with a jar of mimosa, the artist has established the sofa as a real and solid object by using the stripes of the fabric to define its contours, showing exactly the curves of its upholstery. Typically, the artist makes use of the white of the paper in this composition: The background is a sharply seen shape of bright white, as positive and important to the painting as the subect itself. White, says Alan Halliday, brings out the brilliance of colours, and he is always aware of the crucial balance between the space and the painted areas of a picture. A composition is planned "intellectually" – by looking at it and mentally placing the subject within the four edges of the paper, and then putting it down on the support. He does not use a viewfinder or make thumbnail sketches before committing the subject to paper.

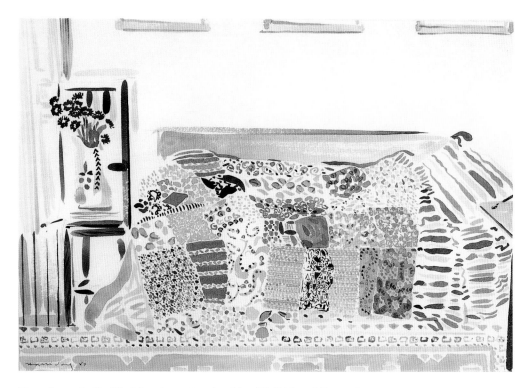

Patchwork Quilt, Montmartre by Alan Halliday. Watercolour. 42cm × 59cm (17in × 23in)

I use lots of white paper around the colours in order to make them sparkle. If there is white space between two areas of watercolour, those colours appear more glowing and brilliant than if the colours met edge to edge. It is exactly the opposite of the way coloured glass windows are made. Medieval craftsmen used to separate pieces of coloured glass with strips of black lead in order to bring out the colours.

Alan Halliday

An antique patchwork quilt in his friend's Paris studio is the subject for this painting. Alan Halliday was attracted by the different patterns and textures of the quilt in which pieces have been stitched into position. The artist has "stitched" these together within the picture, painting them painstakingly as separate scraps of fabric. As with Interior with Mimosa on the opposite page, no shading is used to decribe form. The direction and shapes of the tiny coloured and patterned patches describe explicitly the shape of the bed under the quilt and how the quilt folds and falls over the bed. Here too he uses the clearly defined white background shape to bring out the colourful painted shapes of the subject.

The composition has what the artist describes as a "strong, rectangular grid." Formed by the chair and floorboards, and emphasized by the horizontal stripe in the Persian carpet, the geometry of the grid counters the curvilinear quality, the softness, of the quilt and bed.

Halliday worked with his usual palette of Winsor blue, yellow ochre, cadmium yellow, crimson vermilion, burnt umber, cobalt blue and ultramarine blue.

INDEX

Credits
Illustrations reproduced by kind permission of:
pp 10, 11, 52, Roy Brindley;
p 49, Ian Barby; pp 120-123,
Browse and Darby; p 121 Graham
Barclay; pp 126, 127, British
Architectural Library, RIBA,
London.